A TREASURY OF AUSTRALIAN BUSH PAINTING

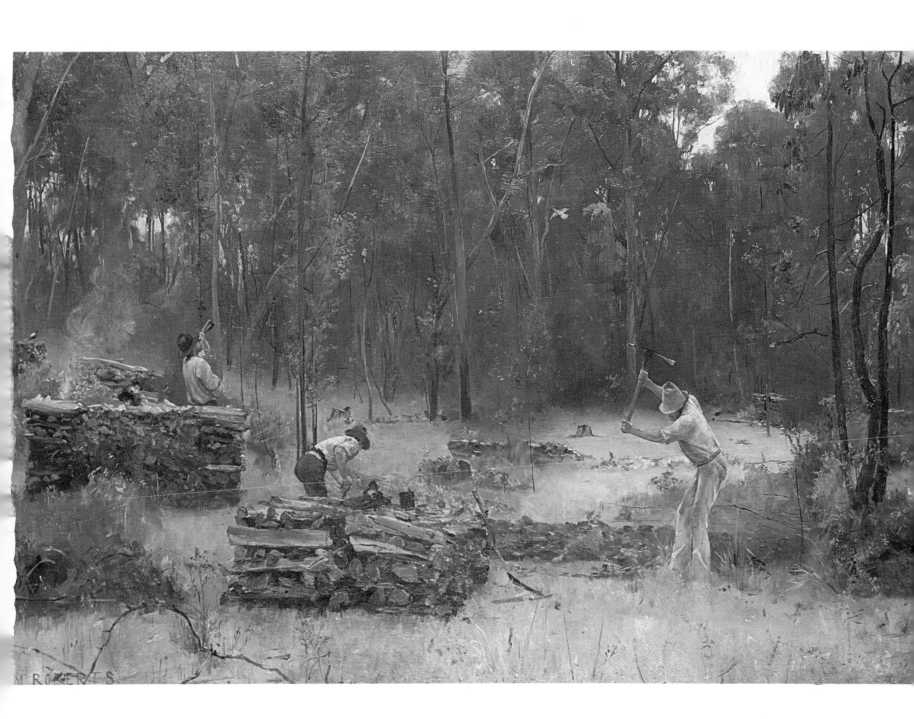

PLATE 1 Tom Roberts *Wood splitters (The charcoal burners)* (1886)

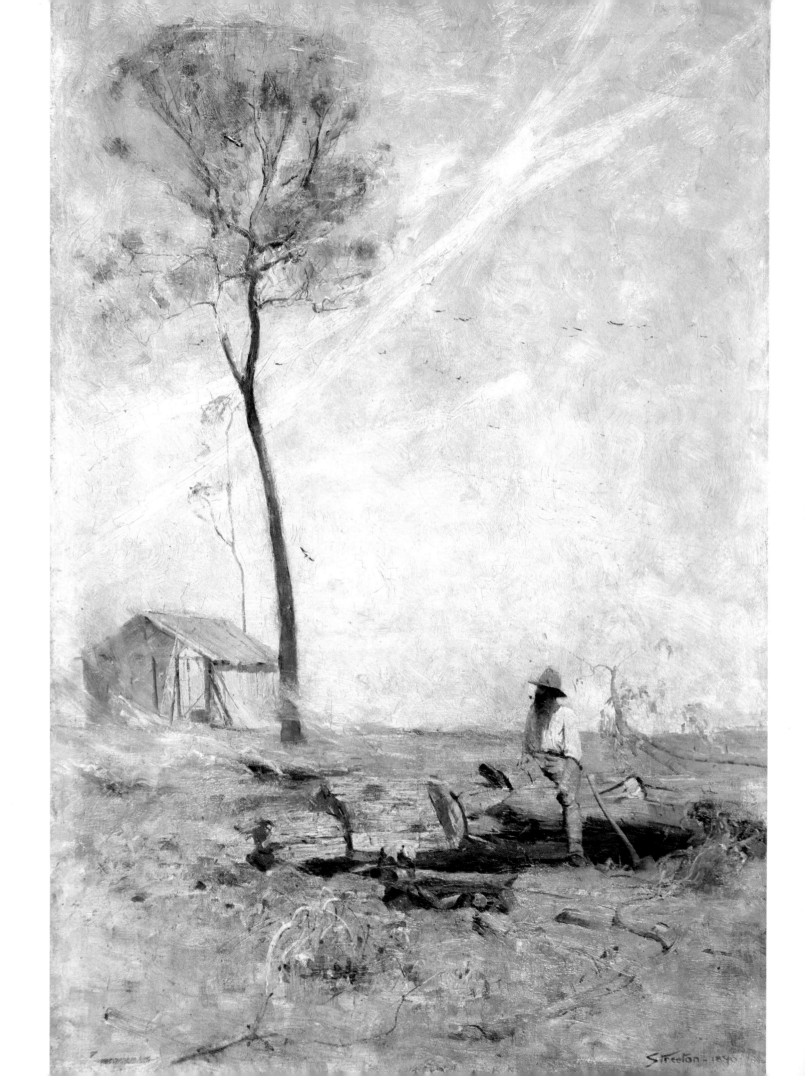

A TREASURY OF AUSTRALIAN BUSH PAINTING

Notes on the painters by
Susan Bruce

VIKING O'NEIL

All the paintings in this book are reproduced by permission of the owners, whose assistance at all stages of production is gratefully acknowledged.

The full title of the painting, the name of the artist and the date of the work are listed adjoining the plates: complete caption details of each work are set out on page 65.

Measurements of paintings are given in centimetres; the titles of paintings follow the form currently used by their owners.

A list of public collections where representative works by the painters included in this book may be seen, will be found on page 69.

Viking O'Neil
Penguin Books Australia Ltd
487 Maroondah Highway, PO Box 257
Ringwood, Victoria 3134, Australia
Penguin Books Ltd
Harmondsworth, Middlesex, England
Viking Penguin, A Division of Penguin Books USA Inc.
375 Hudson Street, New York, New York 10014, USA
Penguin Books Canada Limited
10 Alcorn Avenue, Toronto, Ontario, Canada M4V 1E4
Penguin Books (N.Z.) Ltd
182–190 Wairau Road, Auckland 10, New Zealand

First published by John Currey O'Neil Pty Ltd 1979
First published by Penguin Books Australia Ltd 1987

10 9 8 7 6 5 4 3 2

Copyright © Penguin Books Australia Pty Ltd, 1987

All rights reserved. Without limiting the rights under copyright reserved above, no part of this publication may be reproduced, stored in or introduced into a retrieval system, or transmitted, in any form or by any means (electronic, mechanical, photocopying, recording or otherwise) without the prior written permission of both the copyright owner and the above publisher of this book.

Produced by Viking O'Neil
56 Claremont Street, South Yarra, Victoria 3141, Australia
A Division of Penguin Books Australia Ltd

Printed and bound through Bookbuilders Limited,
Hong Kong

National Library of Australia
Cataloguing-in-Publication data

A Treasury of Australian bush painting.

Includes index
ISBN 0 670 90021 4.

1. Landscape painting. I. Bruce, Susan.

758'.1'0994

Frontispiece: **PLATE 2** Arthur Streeton *The selector's hut* (1890)

List of Plates

List of plates

The Challenge of an Alien Landscape

Perhaps to a greater degree even than the celebrated 'outback', the bush represents the essence of the Australian environment. For most of us the outback is somewhere remote; the ubiquitous bush, wherever we may be, is always close at hand. The bush challenged the abilities of the earliest European painters in this country and it continues to be a major pre-occupation of many contemporary landscape artists. The bush was the birthplace of Australia's culture, the source of its folklore and traditions. Life in the bush provided the inspiration for the first uniquely Australian writers and poets and, fittingly, it was in the characteristic blue-gum country of the south-east that The Australian School of painting had its genesis.

One of the earliest themes of Australian bush painting was the settler's struggle to come to terms and ultimately identify with, his environment. Today, long after the bush has been conquered by the axe and the bulldozer, it remains, for the painter, the symbol of man's encounter with the natural world.

The early settlers saw the native landscape as drab, hostile and above all, alien: their eyes were accustomed to the variety of deciduous trees, autumnal foliage, hedgerows and gentle pastures of England. The evenly-toned olive greyness of Australia's native flora — dominated by the eucalypts, acacias and banksias which kept their foliage regardless of seasonal changes - appeared monotonous and depressing by comparison.

For the first hundred years of settlement the few artists who (either as visitors or residents) portrayed the land were naturally influenced by the artistic conventions of their homeland. Until the 1820s it was also the sole market for their work. The Romantic movement was at its height in England and interest in art focussed largely on the exotic and primitive. The fascinating plant and animal life of the Colony of New South Wales quickly helped establish it as a wonderland of natural curiosities. It was not until the demand for specific information had been satisfied that artists were able to look at the Australian landscape with a less restricted vision.

Most of the early paintings and drawings were made by amateurs — convicted forgers, naval draughtsmen, administrators and botanists — and were thus mostly accurate, if naive observations, unconcerned with the contemporary aesthetic demand for picturesque arrangement. Since both the artist and the scientist were attracted by the vegetation and natural life of the new country, native people, flora and fauna were gradually incorporated into topographical landscape paintings. The few professional artists who experienced the early days of the Australian colonies, however, all tended to rearrange the features of the natural landscape to avoid what they felt was its monotony, and to make it more interesting and familiar to their audience. Thus, in their depictions of the Australian bush, the colours and shapes of English trees predominated for many years, and these painters seemed unable to render, or even suggest, the special and totally different qualities of the Australian light.

The arrival in Sydney of John Lewin, a natural history draughtsman who accompanied Governor Macquarie and the first official party over the Blue Mountains in 1815, marks the first attempt to use detailed botanical observation to suggest the distinctive atmosphere of the bush. Although no

master water-colourist, Lewin's work as a naturalist gave him an honest eye for facts. He noticed, for example, that the leaves of a gum tree do not pile in masses like an oak's but are dispersed on branches wide apart, bunched and transparent. In *Evans Peak* (PLATE 3) the translucent grey-greenness of the eucalypt forest is captured for the first time in paint. *Springwood* (PLATE 4) also re-creates the authentic bush atmosphere as the evening light filters through tall saplings where Macquarie's party prepare to camp.

After this expedition, Macquarie suggested to the British government that Lewin be appointed the colony's first official artist, but nothing came of the proposal. The Lewins found it difficult to make a living in a small community with so few prospective patrons and it was largely through Macquarie's generosity and patronage that they survived. Lewin was held in high regard as a natural history painter, and although his landscapes were not as much admired as those of other artists more adept in exact topography, he was the first to depart from the convention of portraying the country either as an assemblage of curiosities or as a vehicle for picturesque arrangement.

As the fertile lands of New South Wales and Van Diemen's Land were opened up by exploration and their potential for agriculture became obvious, artistic 'views' of the colonies began to make their appearance in England where, it was hoped, they would attract the attention of free settlers. One of the principal producers of these forerunners of the calendar postcard was a convicted forger Joseph Lycett, whose *Views in Australia*, published in 1824, suggested a bland, fertile Arcadia dotted with European trees and the villas of wealthy colonists in a parkland setting. While Lycett's views probably succeeded in making the colonies appear an attractive place to settle, artistically they were largely a tribute to their maker's skill as a forger.

Indirectly, however, the purveyors of such 'views' may have played some part in contributing to the artistic life of the colonies, for the image they promoted — of a new frontier waiting to be explored by the adventurous traveller — attracted a number of professional artists to the infant settlements. One such adventurer was an American, Augustus Earle, who had arrived in Van Diemen's Land in 1825 after having been ship-wrecked for eight months on Tristan da Cunha, during a voyage to India. His father and (particularly) his uncle were well-known painters in America, and as a young man Earle had visited England and studied at the Royal Academy.

While in Australia, Earle satisfied his curiosity by travelling as widely as possible to 'regions previously unvisited by pictorial artists' — south of Sydney to the Illawarra district, north to Port Macquarie and west over the coastal range to the newly-opened Bathurst Plains. As well as making many drawings and sketches, Earle set up a studio in Sydney and painted portraits of the leading members of the colony. On his return to England he developed some of his sketches into oil paintings and, in 1838, ten years after he had left Australia, the exhibition of one of his large colonial subject pictures attracted much attention at the Royal Academy. *Cabbage Tree Forest* (PLATE 5), which is similar in treatment to the Royal Academy exhibit, conveys much information about the native flora, though in accordance with the romantic convention of the period the artist has dramatised the scene to emphasise its exotic elements.

Some of the most important early works to highlight the non-English characteristics of the Australian bush were made by another emigrant professional artist, John Glover. Glover was sixty-three when he came to Australia. He was a widely-travelled and quite wealthy man who had exhibited at the Royal Academy, had his own gallery in Old Bond Street and a fashionable clientele. Soon after he arrived in Hobart in 1831 to join his three sons, he acquired a property, which he named 'Patterdale', on the banks of the River Nile at Ben Lomond. In *The River Nile* (PLATE 6) the smooth-boled, sparse-leaved trees exhibit none of the variety of shape and texture which are so much a feature of the English woodland. Although Glover's style was influenced by masters of the previous century — Claude Lorrain and Salvatore Rosa in particular — his perceptive observation and skill enabled him to convey the unique characteristics of the local landscape. The fact that Glover, despite his age and background of traditions, quickly developed a feeling of familiarity with the bush around him, seems evident in *Launceston and the River Tamar* (PLATE 7) . Perhaps his family's success in farming what

was obviously very productive land led him to view the surrounding countryside more benignly than some of his contemporaries.

Glover's very personal interpretation of the landscape contrasts sharply with the academic view presented by the Austrian-born Eugene von Guerard who arrived in Victoria in the early 1850s after twenty years travelling and studying in Europe where his father had been court painter to Emperor Francis I of Austria. While *The River Goulburn near Shepparton* (PLATE 8) and *Fern Tree Gully* (PLATE 9) demonstrate his ability to reproduce exactly what he saw in the belief that his visual experience of nature was the absolute truth, the colour and atmosphere of *Mt Kosciusko* (PLATE 10) is more European than Australian in feeling. At the same time it could be said that von Guerard's desolate expanses of virgin forest confirm the view of Australia described by the novelist Marcus Clark as a place of 'hardship and weird melancholy'.

The discovery of gold in the 1850s brought wealth, people, activity and ideas into the Australian colonies. Samuel Thomas Gill, who had arrived in South Australia from Somerset in 1839 at the age of twenty-one with little formal training, had the skill and power of observation to capture the changing attitudes of the people to their environment. Gill knew the Australian landscape well. He had trekked deep into inland South Australia with the explorer Horrocks, and when gold was discovered in Victoria he joined the throng of diggers on the journey (mostly on foot) from Melbourne to the diggings at Ballarat and Bendigo. On his travels Gill lived as a bushman and was close to the spirit of the bush: he experienced the solidarity and tenuous security of the camp fire on innumerable occasions. In his sketches and paintings various features of the landscape — such as dead and fallen timber, used by earlier artists to stress melancholy — are reduced to form an atmospheric background for the people exploring and living in it. His *Avengers* (PLATE 11) move through the bushland scene with an air of familiarity and complete assurance; they are in fact part of it. Man is no longer alien to his environment, formidable though it may be. Gill's portrayals of bush life have often been likened to the work of the Englishman Thomas Rowlandson but he has also been truly called 'the most Australian' of all the colonial artists.

Gill's completely Australian vision anticipated that of most of his contemporaries and, indeed, many younger artists. Several paintings of the late 1870s and early 1880s revealed, nevertheless, that a transition was under way. Henry Rielly's *Landscape near Ballan* (PLATE 13) for example, exhibits a curious mixture of the primitive and sophisticated: an amalgam of the English tradition and the Australian vision. In Edward Roper's *Kangaroo hunt* (PLATE 12) the accurately-observed detail of the antipodean bush is combined with the English fox-hunt poses of the horsemen to reveal the painter's well-developed sense of the incongruous. William Ford's *Picnic party at Hanging Rock* (PLATE 14), although rendered in the English art school tradition, depicts the rock area as a splendid native bushland park, peopled with fashionable figures at ease in their surroundings.

Although the inclination was still to force the subject into an inappropriate stylistic presentation, the artist was now becoming aware of, and perhaps even drawing attention to, the essential differences between his native and adopted country. Almost one hundred years after the first settlement, the bush is now seen as less formidable, less alien, as the settlers begin to feel some degree of harmony with their new environment.

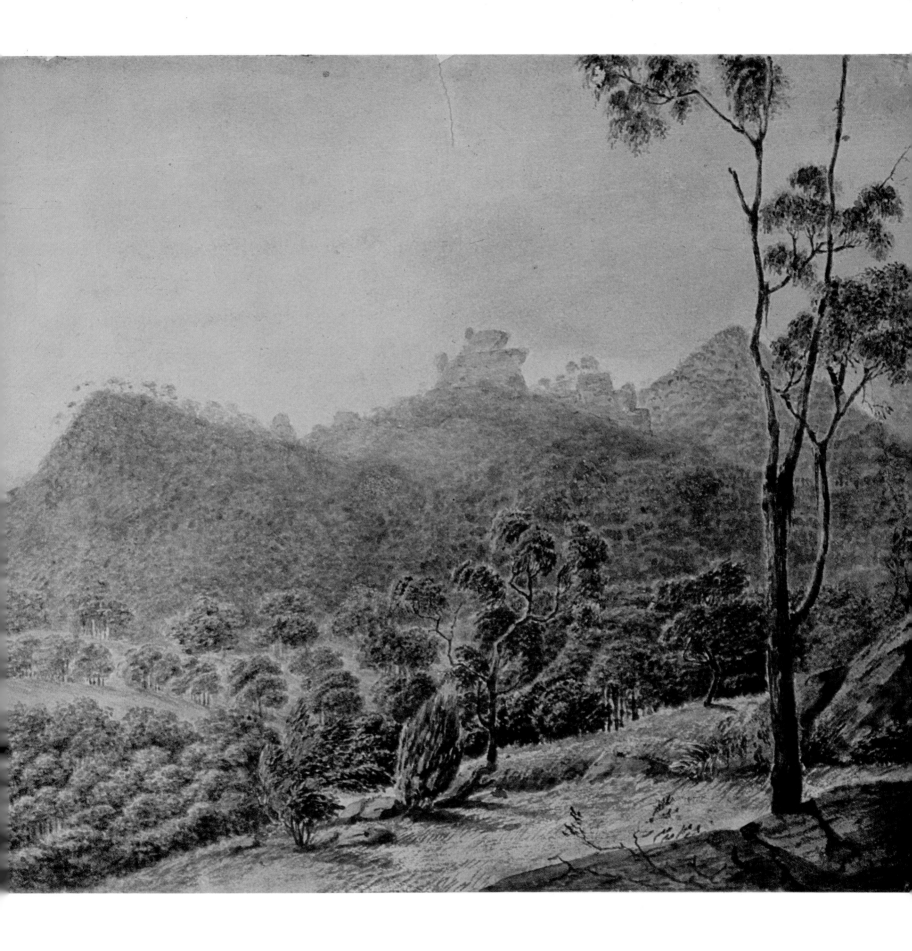

11 PLATE 3 John Lewin *Evans Peak* (1815)

PLATE 4 John Lewin *Springwood* (1815)

PLATE 5 Augustus Earle *Cabbage Tree Forest, Illawarra, New South Wales* (c. 1827)

PLATE 5

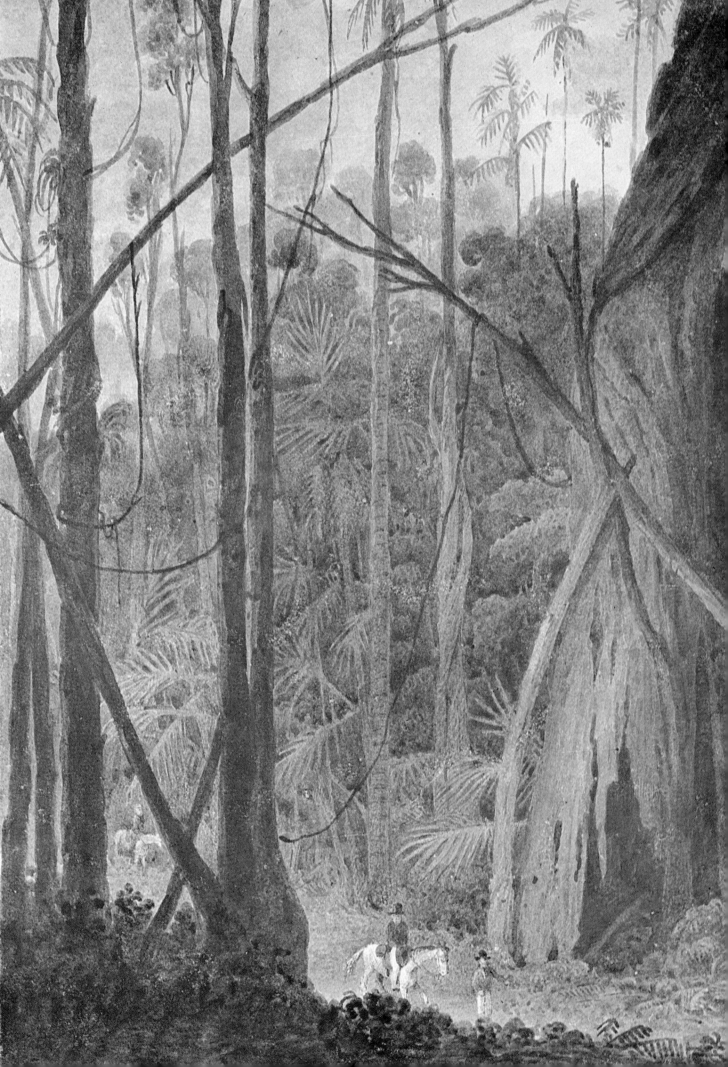

PLATE 6 John Glover *The River Nile, Van Diemen's Land* (c. 1838)

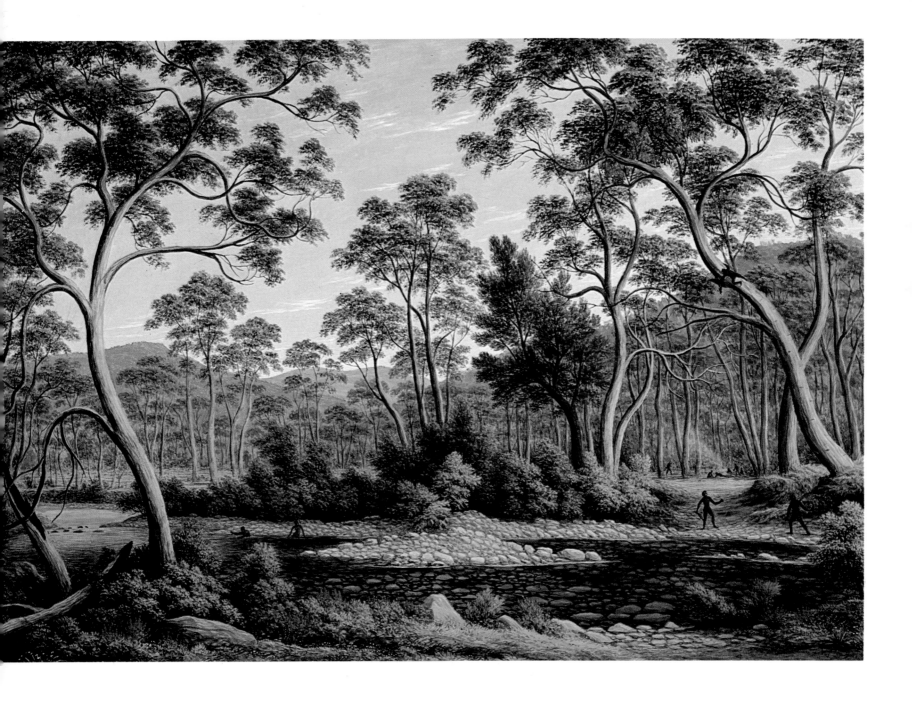

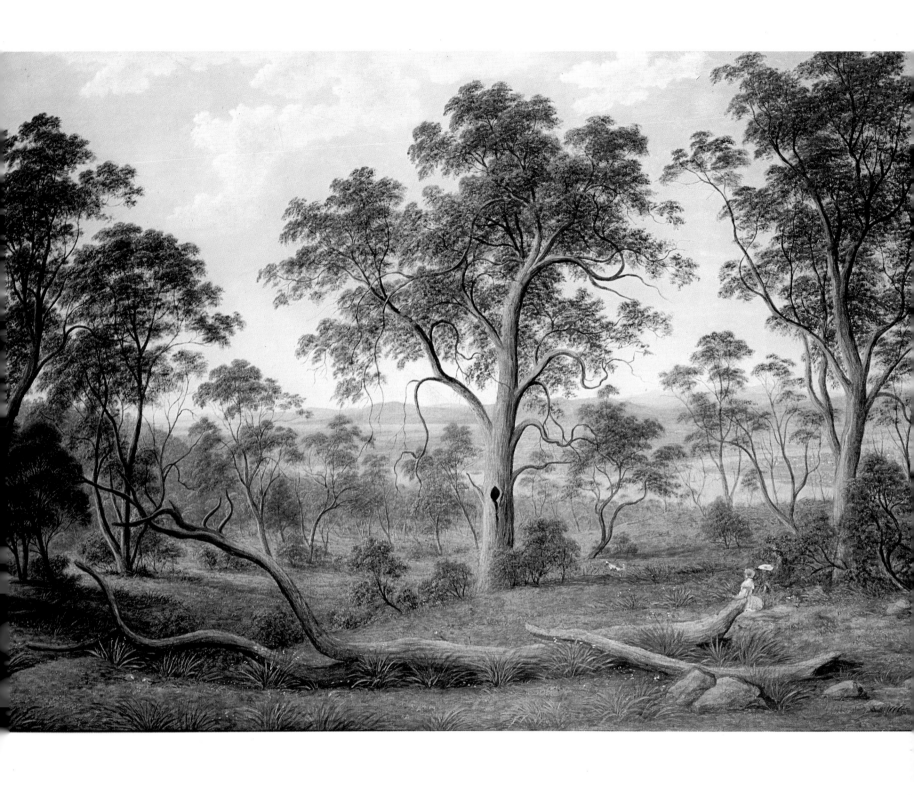

15 PLATE 7 John Glover *Launceston and the River Tamar* (c. 1834)

PLATE 9

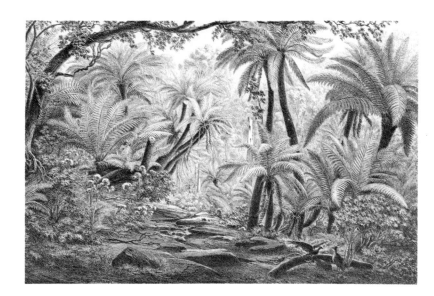

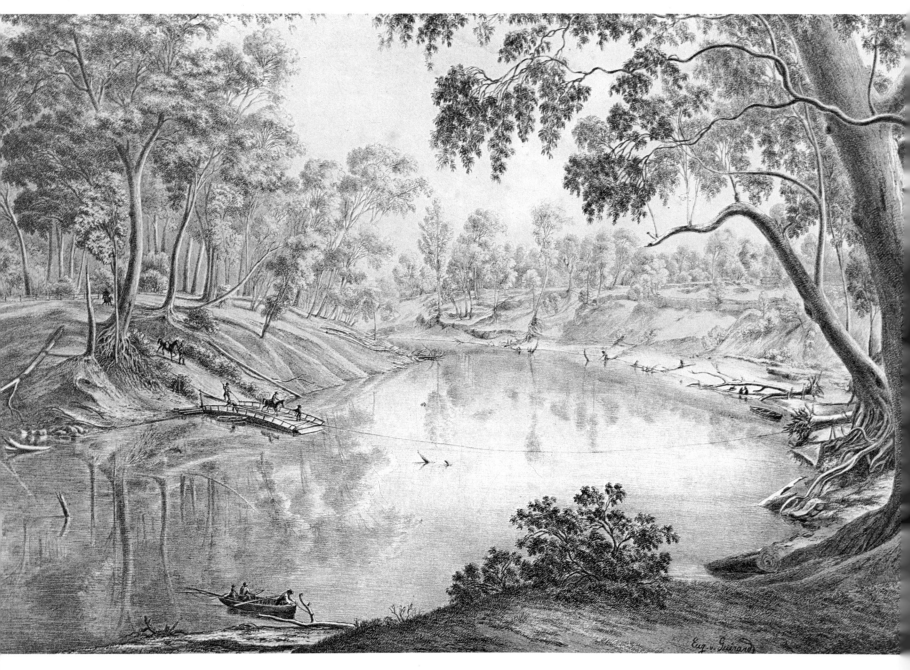

PLATE 10 Eugene von Guerard *Mount Kosciusko seen from the Victorian border
(Mount Hope Ranges)* (1866)

PLATE 8 Eugene von Guerard *The River Goulburn, near Shepparton* (c. 1862)

17 PLATE 9 Eugene von Guerard *Fern Tree Gully, Dandenong Ranges, Victoria* (c. 1856)

PLATE 11 S. T. Gill *The avengers* (undated)

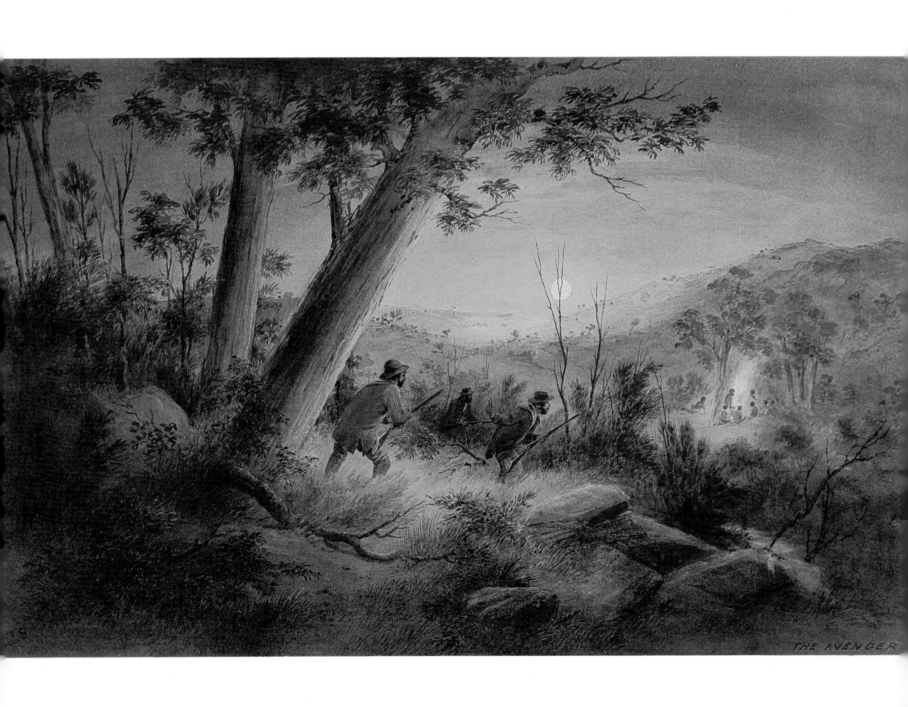

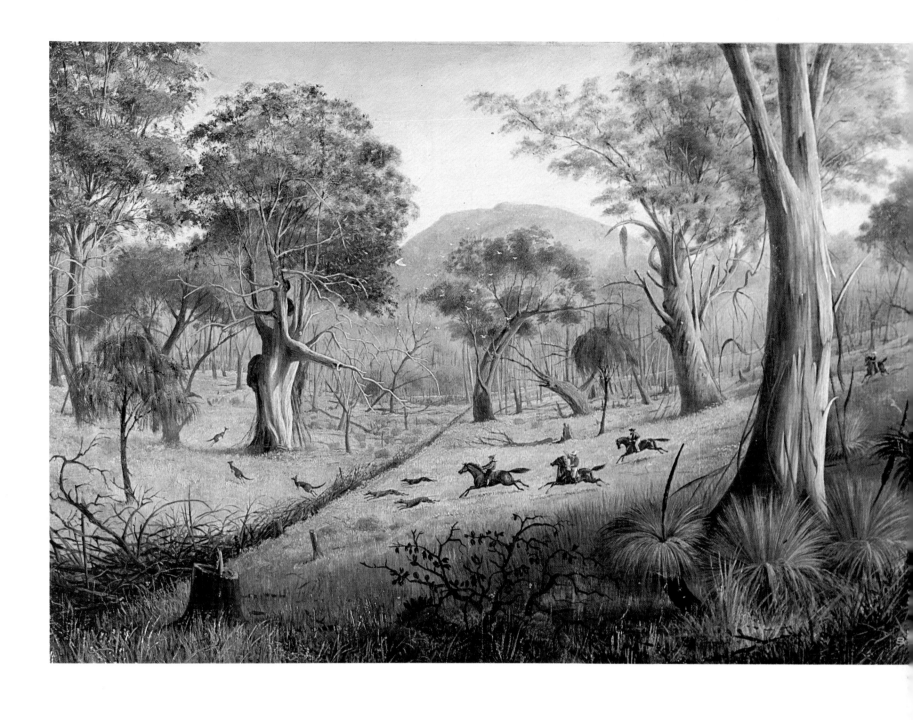

PLATE 12 Edward Roper *Kangaroo hunt, Mt Zero, the Grampians, Victoria* (1880)

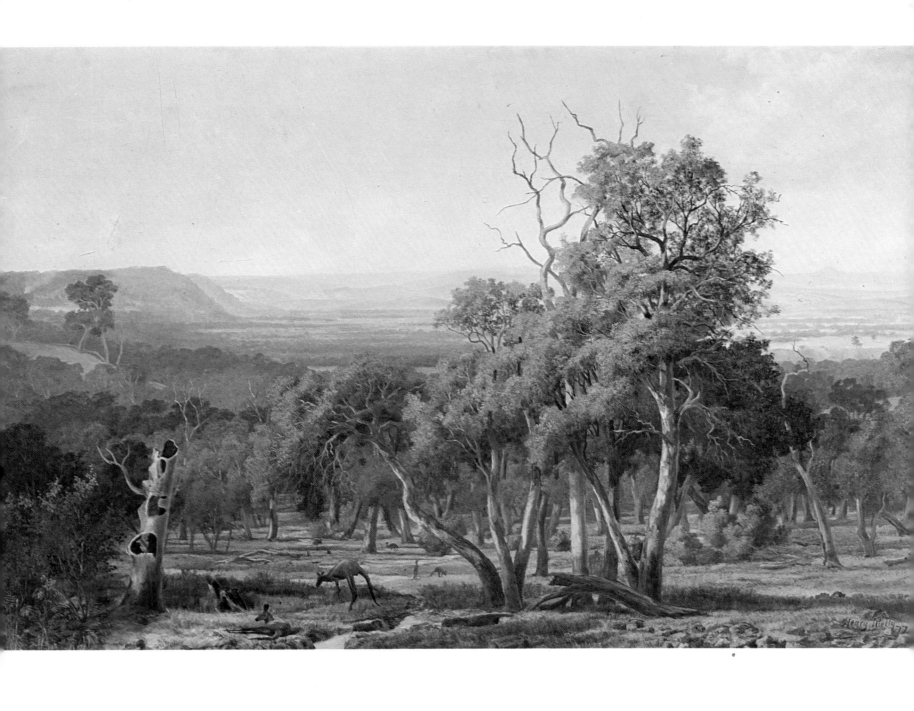

PLATE 13 Henry Rielly *Landscape near Ballan, Victoria* (1877)

The Box Hill Camp & the Heidelberg School

The emergence of a distinctly Australian school of painting can be traced back to the late 1870s. The great economic expansion which followed the gold rushes of the preceding decades had seen Australian society change from a collection of frontier towns to a series of larger urban communities whose populations could now afford to support an interest in the arts. By the early 1870s public art galleries had been established in Melbourne and Sydney; both cities had begun to form public collections and to set up professional painting classes. The most important art school was attached to the National Gallery of Victoria which shared teachers with the Artisan's Schools of Design in suburban Collingwood and Carlton, two of a number of schools established to provide opportunities for apprentices to learn more about design than they could from their trade and also to help those who wished to become amateur or professional painters but could not afford private tuition. Most of the teachers were European but many of the pupils at these schools had been born in Australia. For the first time, native-born Australians outnumbered the immigrant population.

In Melbourne one of the most influential teachers of this period was Abram Louis Buvelot, a Swiss-born painter influenced by the Barbizon school, a group of French artists who made a practice of executing their realistic paintings of peasant scenes directly from life. (Until this time most paintings were made in the artist's studio from sketches and memory.) Using this 'open-air' approach, Buvelot discovered a fund of unsuspected beauty in the settled rural countryside of the Port Phillip area. The natural arrangements of fallen limbs in his *Bush scene* (PLATE 15) and the variety of colour of the eucalypt in *Mt Martha from Dromana's hill* (PLATE 16) focussed attention on the picturesqueness of the domestic Australian landscape. Buvelot's scenes have none of the forbidding melancholy of his European contemporary von Guerard; they are scenes of peace and rural plenty, indicative of the general feeling of prosperity that was prevalent at the time. Buvelot gave classes at the Artisan's school at the Trades Hall in Carlton, and it was during this period that the student Tom Roberts — later to be hailed as the 'father of Australian painting' — first came into contact with the man who had pioneered such a significant innovation in Australian landscape painting.

Roberts came to Australia from England at the age of thirteen in 1869. For a time he worked for a Collingwood photographer, but after winning the drawing prize at the Collingwood school he was able to join the gallery school. Encouraged to complete his studies overseas, Roberts spent four years studying and travelling in Europe during which time he became aware of the French Impressionist movement and its concern with nature, open air and the qualities of light. A short time after his return to Melbourne in 1885 Roberts and two friends, Frederick McCubbin and Louis Abrahams set up an artists' camp site in bushland country on the fringe of Melbourne where they began to paint the native bush using some of the techniques of rendering light and colour which had transformed modern French painting; here the Australian Impressionist movement had its beginnings.

Roberts' realistic, closely-observed paintings of the bush show it as a place to be lived in and loved. His 'Box Hill' paintings such as *The artists' camp* (PLATE 17), *The splitters* (PLATE 1) and

A summer morning tiff (PLATE 18) continued and developed the tradition begun by Buvelot of selecting an intimate scene and using softly modulated colours to evoke the atmospheric tranquillity of the bush. But if Roberts was to go on to become the 'father of Australian painting' it was his fellow-student Frederick McCubbin who was to become, more than any painter of his time and perhaps even of our own, the great painter of the Australian bush.

In two of McCubbin's early works, *The lost child* (PLATE 20) and *Down on his luck* (PLATE 19), the bush becomes, for the first time in Australian painting, a participant in the story which the artist is presenting. These works belong to a series of 'social history' paintings in which McCubbin explored many of the themes of pioneering life. They are remarkable for the faithful and detailed rendering of the native flora: the peeling bark, the glaucous eucalyptus leaves and the delicate native grasses. McCubbin is concerned with observing the beauty of the natural surroundings but at the same time his figures invest the paintings with deep human significance: the bush is, for the lost child, a hostile and unsupportive environment; for the settler down on his luck, an unrelenting adversary.

During the summer months the 'Box Hill' artists moved camp to the beach resorts of Beaumaris and Mentone on the shores of Port Phillip Bay, and it was here that the young painter Arthur Streeton was introduced to the group. His interest in and skill at drawing led him to become an apprentice lithographer to a well-known printing firm and he enrolled as a part-time student at the National Gallery school. Streeton had already exhibited at the Australian Artists' Academy and been classified by the *Argus* art critic as 'belonging to the general leaning of our young artists and art students towards the French method of landscape painting'. Streeton joined the others at the Box Hill camp, but tended to paint further afield, being more interested than his companions in capturing the light and sense of space of the open countryside. His sensitive early sketch of Gembrook in the Dandenong ranges beyond Box Hill (PLATE 22) captures with great economy the newness of the land recently reclaimed from the bush. *Impression* (PLATE 21), which was probably painted in one of the rural settlements like Heidelberg, to the north-east of Melbourne, is a good example of the brilliance with which he was able to capture the immediate atmosphere of his subject in small, swiftly-executed paintings.

During a painting trip in the valley of the Yarra River near Heidelberg, Streeton found an old weatherboard house, 'Eaglemont', which he was given permission to use as another artists' retreat. As a result, the Box Hill camp was abandoned and 'Eaglemont' became the headquarters for what was to be known later as the Heidelberg School of Australian painting. Here Streeton, Roberts and some of their fellow artists were joined by Charles Conder, a talented young Englishman whom Roberts had met in Julian Ashton's painting group in Sydney and persuaded to join the Melbourne artists. The romantic feeling for nature that the young painters experienced and shared is beautifully expressed in Streeton's *Twilight pastoral* (PLATE 23), a view from 'Eaglemont' that all were to remember with nostalgia in later years. Similarly, *Blossoms, Box Hill* (PLATE 24) expresses both the joy of sunshine and the optimism of youth: the central theme of the short, idyllic years during which the Heidelberg artists worked enthusiastically to translate their delight in the local landscape into paint.

In 1889 Roberts organised an exhibition of the Heidelberg group's work to demonstrate to the public their impressionist aims. The now legendary '9 x 5 exhibition', although unfavourably reviewed by the critics, was the starting point from which images of the country began to capture public imagination. Most of the Heidelberg artists had grown up in towns and had discovered the beauty of the bush through their art. They embraced their modified form of impressionism as a technique to present the appearance of the landscape with greater truth and fidelity, and used it to convey their own new-found appreciation and understanding of their natural surroundings. Many members of the group, particularly Roberts, Streeton and McCubbin, held strongly nationalist sentiments, but it was not until the 1920s that their work was identified as a national expression in painting.

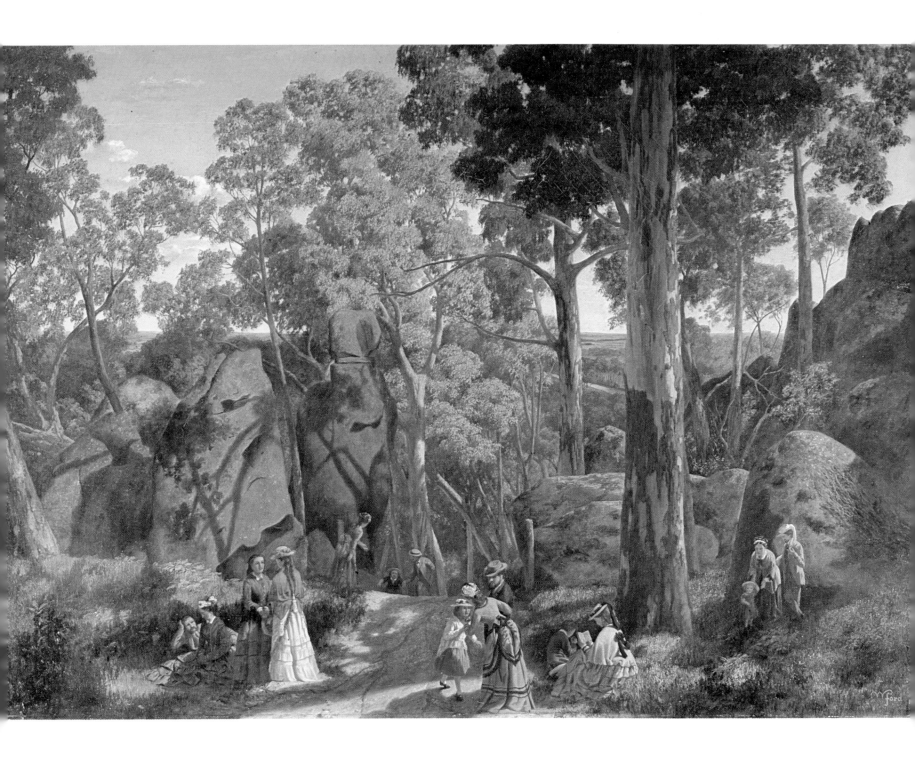

23 PLATE 14 William Ford *Picnic party at Hanging Rock near Mt Macedon* (1875)

PLATE 15 Louis Buvelot *Bush scene* (1878)

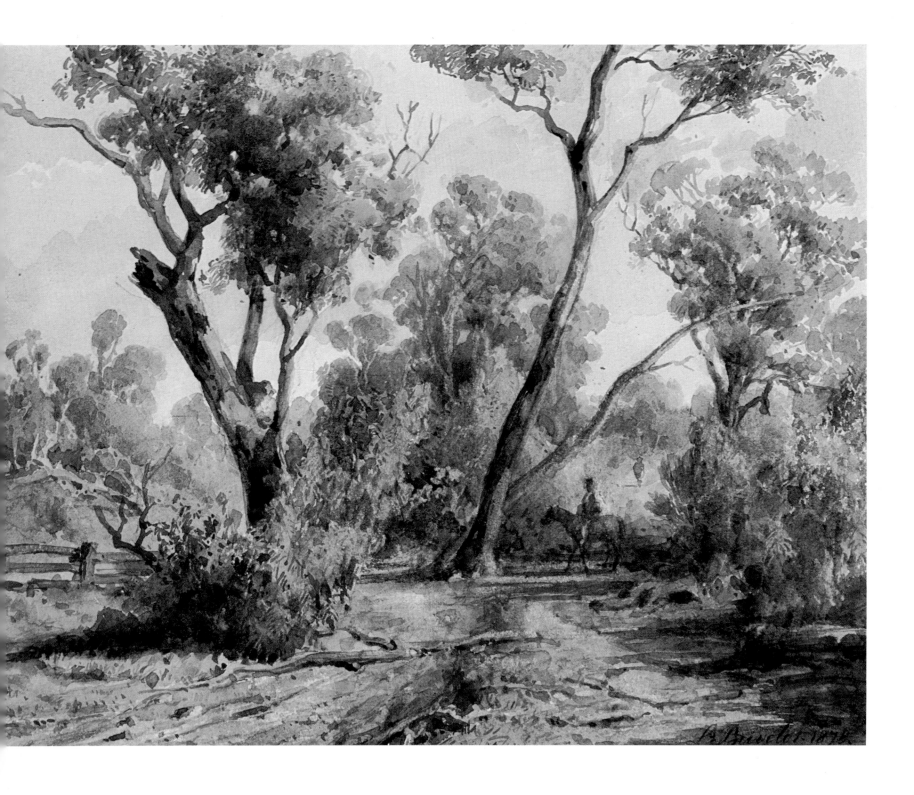

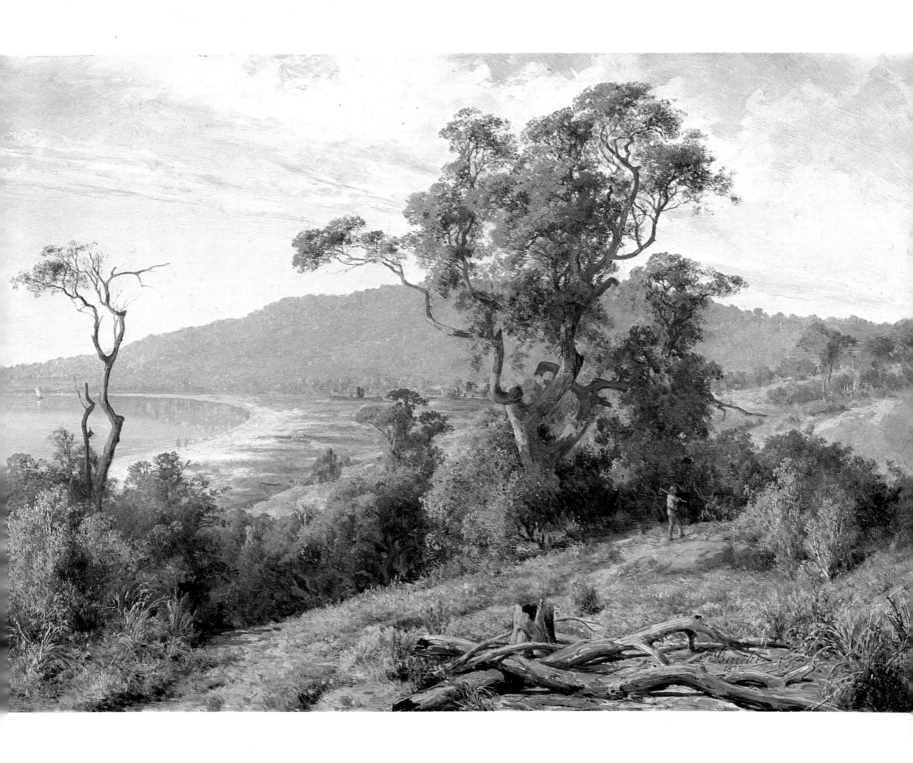

25 PLATE 16 Louis Buvelot *Mt Martha from Dromana's hill* (1877)

PLATE 18 Tom Roberts *A summer morning tiff* (1887)

PLATE 17 Tom Roberts *The artists' camp* (1886)

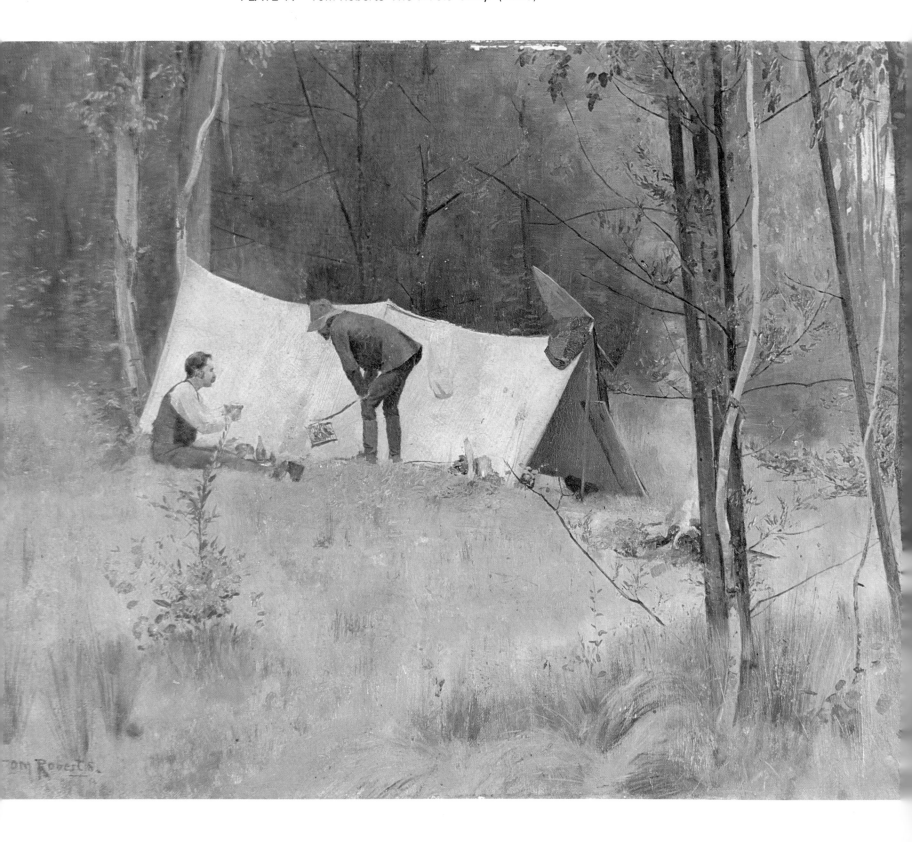

PLATE 18

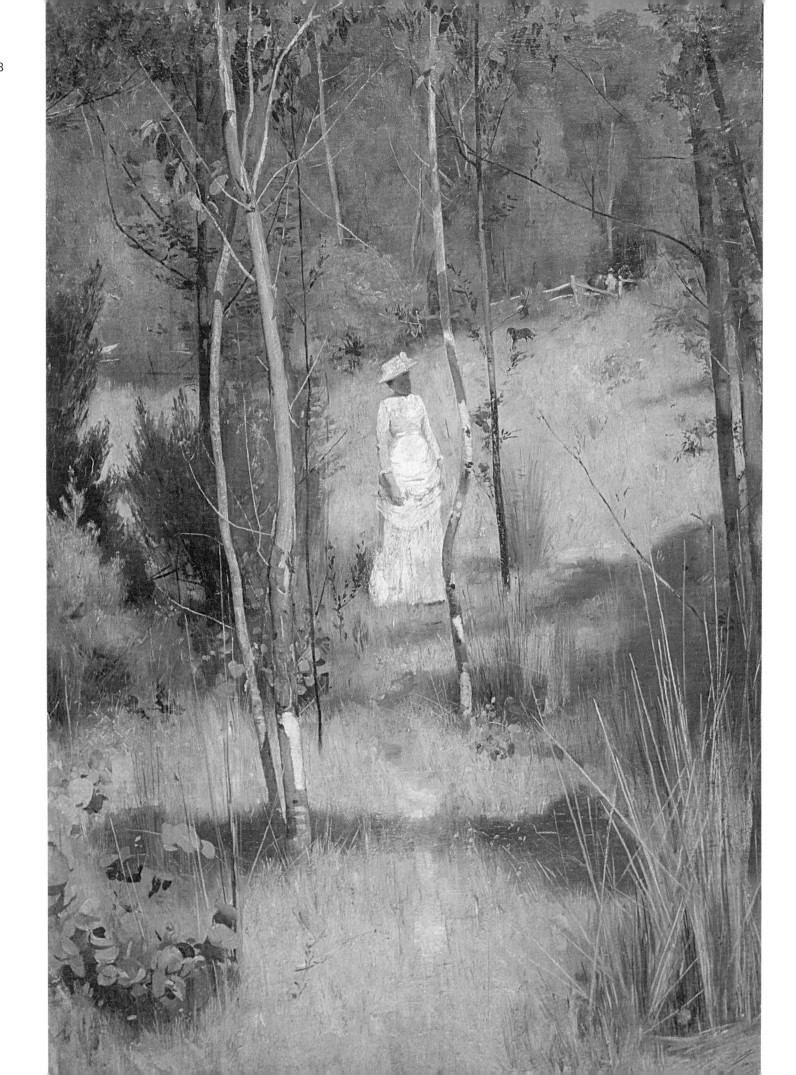

PLATE 20 Frederick McCubbin *Lost* (1886)

PLATE 19 Frederick McCubbin *Down on his luck* (1889)

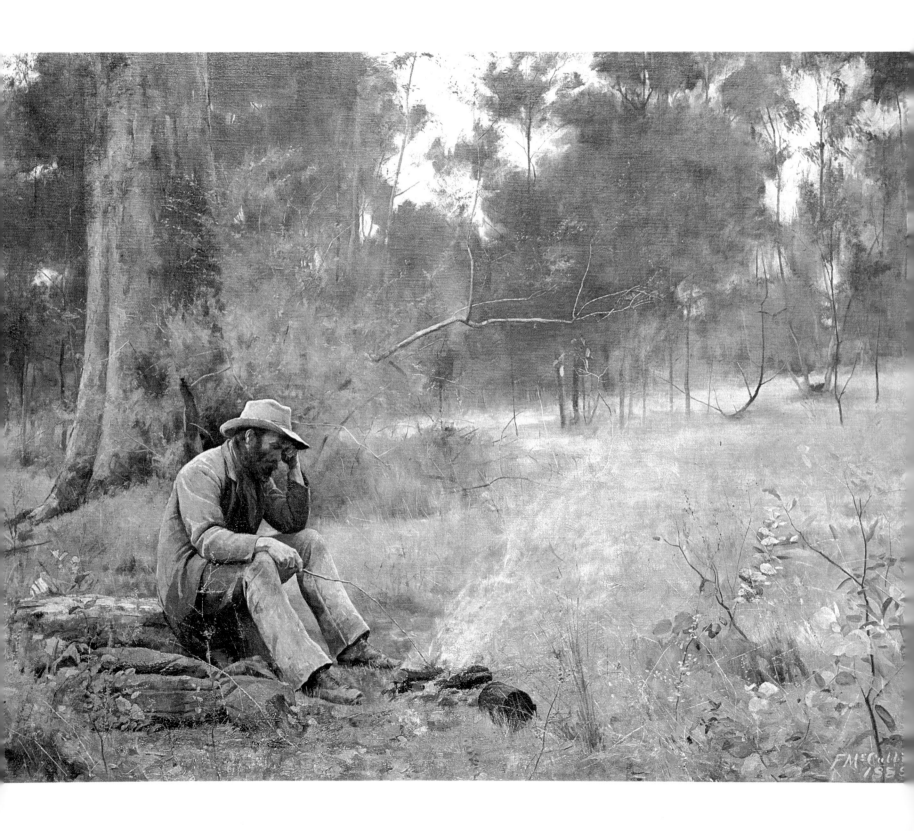

PLATE 20

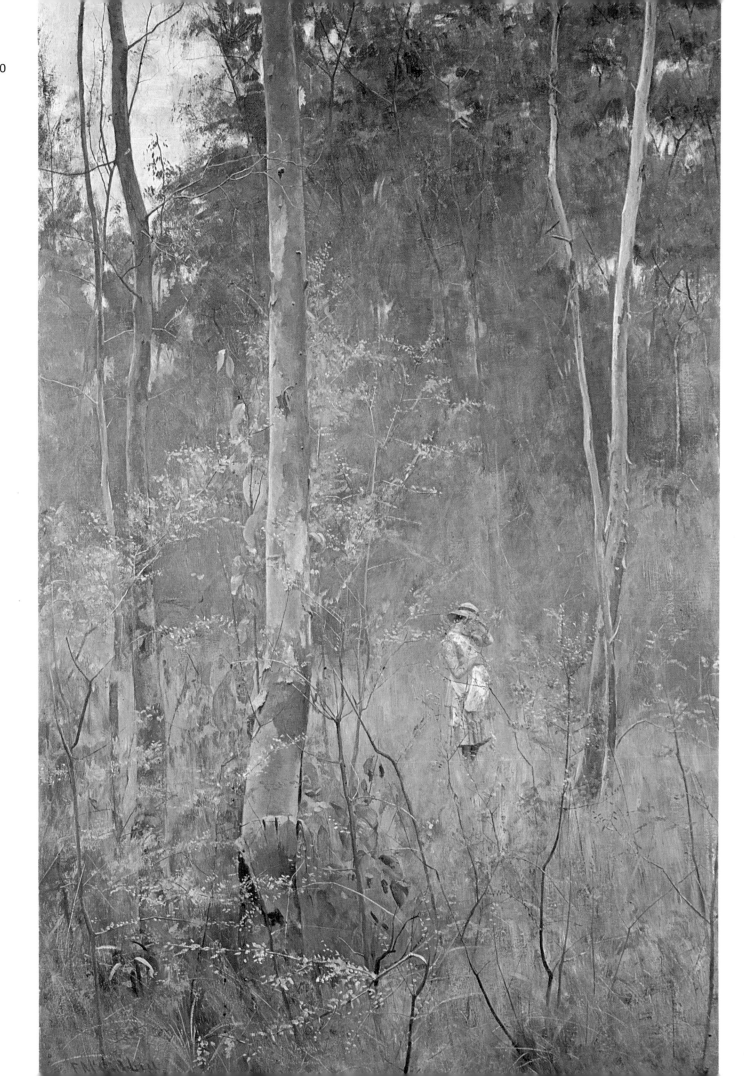

29

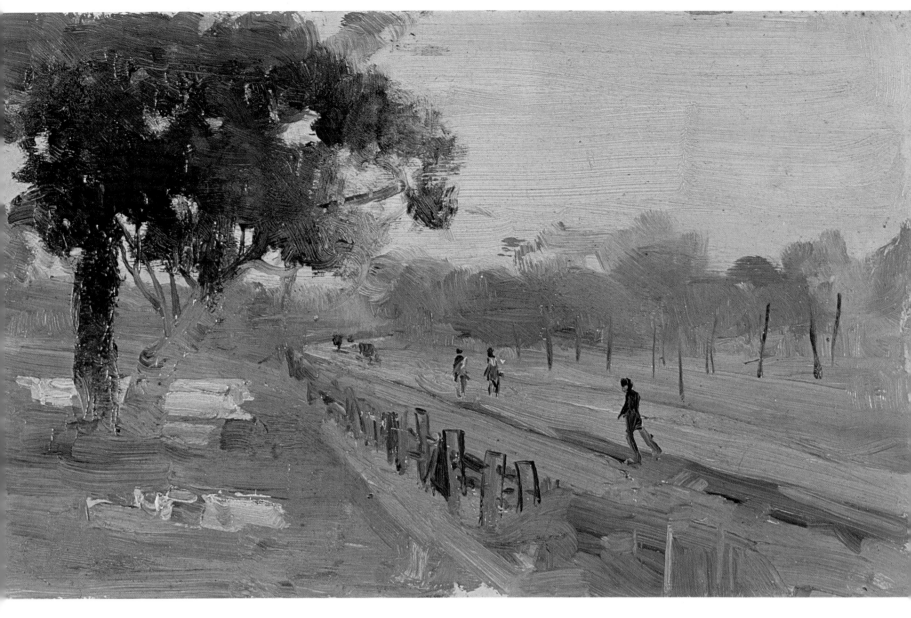

PLATE 21 Arthur Streeton *Impression — roadway* (1889)

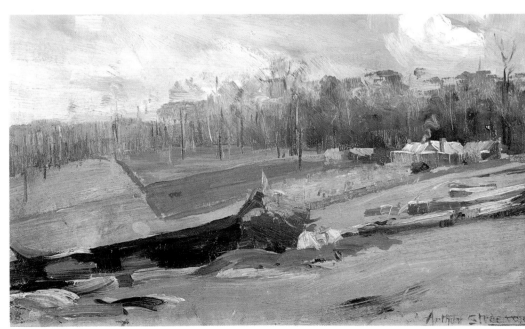

PLATE 22 Arthur Streeton *The clearing, Gembrook* (1880)

PLATE 23 Arthur Streeton *Twilight pastoral* (1889)

PLATE 23

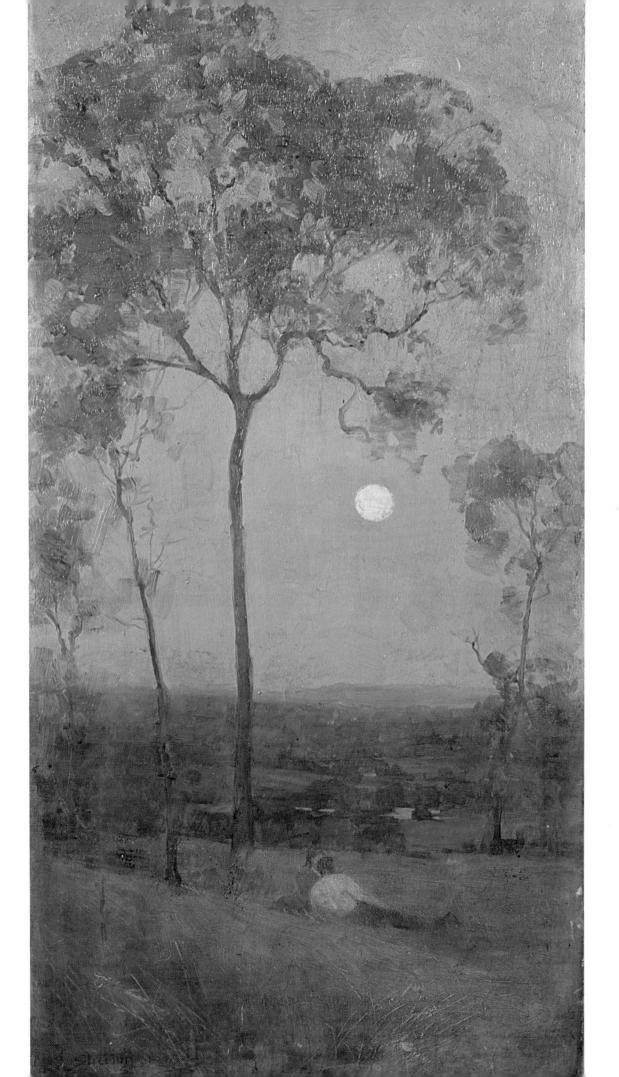

PLATE 25 (Opposite) Frederick McCubbin *The letter* (1884)

PLATE 24 Arthur Streeton *Blossoms, Box Hill* (1890)

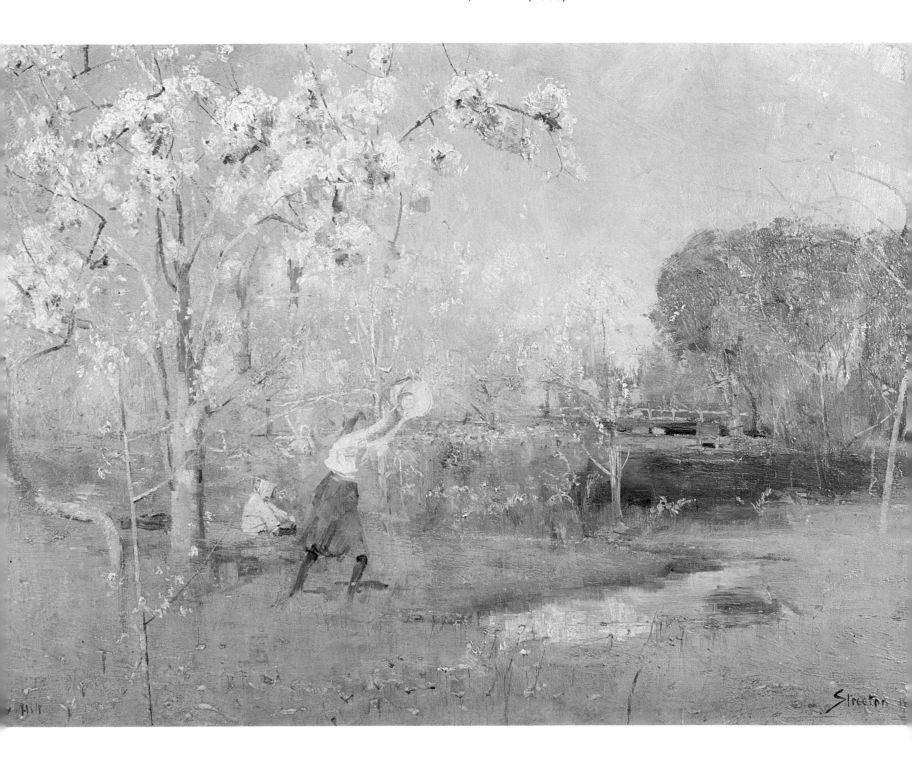

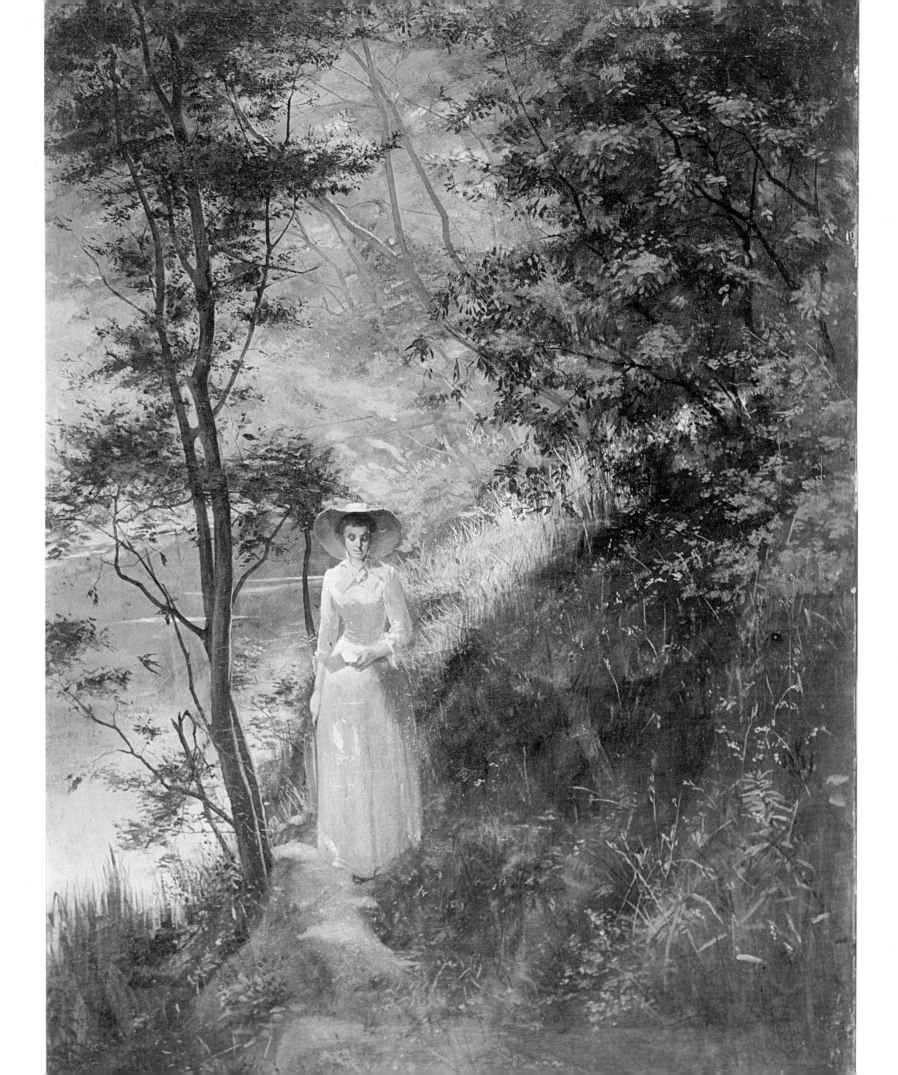

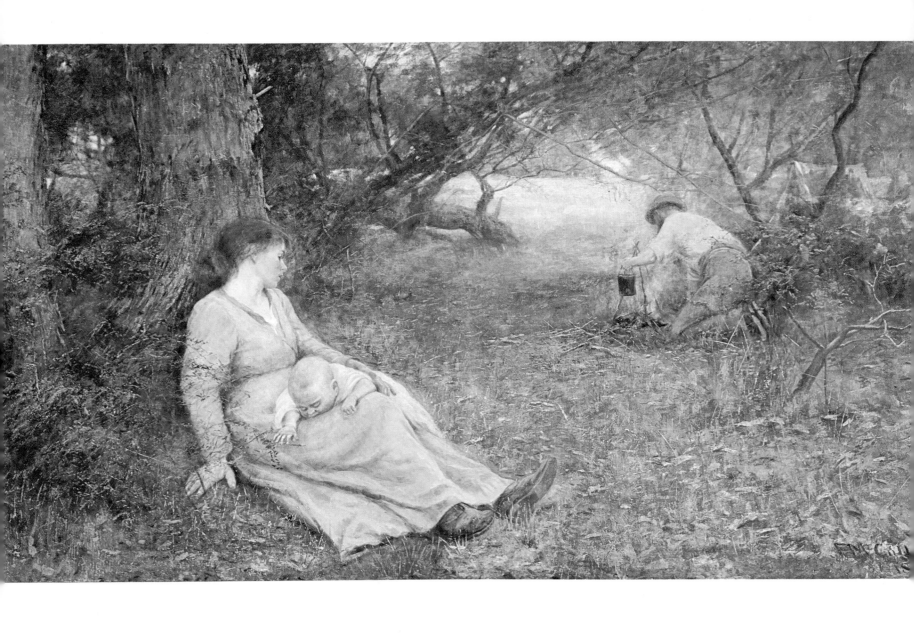

34 PLATE 26 Frederick McCubbin *On the wallaby track* (1896)

Exploring the Themes of Bush Life

Depiction of life in the bush continued to be a recurring theme of painting in Australia at the end of the nineteenth century, despite the fact that a greater proportion of the population now lived in the cities. However, there were two distinct schools of thought as to the artistic techniques most appropriate to the Australian theme. The aim of the Heidelberg artists to create a distinctively Australian art was not shared by all their fellow students at the National Gallery school. Many of the teachers there were trained in the academically-inclined art schools of Europe and therefore persuaded their most talented students that a successful career began either in London or Paris. The preference of Australian art buyers for the works of acceptable European masters reinforced this attitude.

John Longstaff, who won the National Gallery's first travelling scholarship in 1887, was a good example of the more conventional, academically-inclined artist of this period. He had spent his childhood in the Victorian countryside and therefore had first-hand experience of many of the natural disasters, such as famine, flood and fire, common to bush life. His scholarship-winning picture *Breaking the news* was based on a vivid childhood memory of a mining disaster in his home town of Clunes; *Gippsland, Sunday night* (PLATE 27) was painted after a trip through the country which bushfires had recently devastated. Longstaff's anecdotal, faithfully-detailed but rather melodramatic paintings of Australian bush life were far more popular when first exhibited than any of Roberts' or McCubbin's works of similar themes had been.

David Davies was another contemporary of the Heidelberg artists who continued his studies in Europe and eventually became an expatriate. Before his first visit to Paris in 1890, Davies was very sympathetic to the ideals of the Heidelberg group and showed a remarkable ability to capture the very feel of the Australian landscape. The effect of the midday sun on the colours of the bush is admirably realised in his painting *Golden summer*, painted on one of his regular weekend trips to the camp at Eaglemont. However, where *Golden summer* typifies the Heidelberg movement in both subject matter and technique, *From a distant land* (PLATE 28) is purely Victorian in its subject matter of nostalgia and mood. Home is far distant in the letter-reader's mind and so too is the door-framed reality of the Australian bush. Considering the stark realism of Davies' earlier work, and the lyrical romanticism of his Australian landscapes painted on his return four years later, it is tempting to attribute this excursion into a popular genre to the desire to raise money for his journey abroad.

The Impressionist movement in Australia (as it had been in France) was ahead of its time and of public taste. It had only a short-lived influence on its own generation and the movement of artists to Europe continued to reinforce the trend towards academic realism. This in turn coincided with both Streeton's and Roberts' ambition to capture the essence of particular aspects of the Australian landscape which identified and gave definition to the newly-emerging feelings of nationalism. The need for larger canvases to depict more ambitious themes called for different techniques; thus Impressionism gave way to the careful artistry and accurately-observed detail of Roberts' great pastoral paintings and Streeton's Hawkesbury landscapes.

Roberts' painting of the artists' camp at Sirius Cove (PLATE 34) where he and Streeton were able to live very cheaply during the depression years, depicts the bush as offering security and protection to the settlement within it, which indeed it was. From here, Roberts travelled inland, sketching and painting what are probably now his best-known works. His delight at being in the bush, his fascination with pastoral life and work and his desire to express the dignity of labour is well realised in *The golden fleece* (PLATE 30). Originally called *Shearing at Newstead*, this painting was one of a series of history pieces designed to capture the identity of Australian life. Unfortunately for Roberts, it was some years before the public responded to this identity, preferring the more classical heroism of the academic school. In the light of the contemporary taste in art, the decision of the Art Gallery of New South Wales to acquire *Shearing at Newstead* soon after its completion was an indication of its forward-looking policy at that time.

The depth of Roberts' feeling for his subject matter and his meticulous craftsmanship link him closely with Henry Lawson who was portraying similar landscapes in prose. Both worked from life, and even though an event such as a hold-up was probably outside Roberts' experience, *Bailed up* (PLATE 31) demonstrates his ability to reconstruct such situations as realistically as possible. This painting was probably inspired by the painter's friendship with a Cobb & Co driver, Bob Bates, who had been involved in a hold-up near Inverell, New South Wales. For the sake of accuracy, Roberts hired a stage-coach, horses and models and, instructed by Bates, arranged all in a realistic tableau which he painted from a specially-erected platform. *Bailed up* was exhibited in 1895 at the first exhibition of the New South Wales Society of Artists, a group established by Roberts and other artists in opposition to the amateur-dominated Arts Society of New South Wales. The painting was not sold, however, and remained in Roberts' possession until some twenty years later when he reworked it — reputedly painting in a different bush background — and exhibited it at the Macquarie Galleries where it was bought for five hundred guineas and placed on permanent loan with the Art Gallery of New South Wales.

A friend of Roberts' wrote 'that no artist has yet come near him in depicting the fierce glare of the hot sun, so typical of the Australian heat'. *On the Timburra* (PLATE 29) not only records gold-mining but also captures immediately the atmosphere of the Australian hinterland where the sun glares down, bleaching all colour from the earth. Yet despite Roberts' ability to reproduce so successfully the essence of bush life and the Australian landscape, portraiture remained his main source of income. It was not until after his death that the value of this period of his work was fully realised and appreciated.

While Roberts and Streeton were finding inspiration on their journeys inland, their colleague of Box Hill days, Fred McCubbin, continued to paint in the environs of Melbourne. *On the wallaby track* (PLATE 26) and *Lost* 1907 (PLATE 32) continue McCubbin's theme of the difficulties and disappointments of eking out an existence in an untamed land. In contrast to his earlier work on this theme (for example *Down on his luck*) and the realism of Streeton's and Roberts' paintings at that time, McCubbin's pictures now show the impact of Impressionism. The technique of applying loose flecks of paint freely with a palette knife had the effect of relating his figures more naturally to their surroundings. These paintings then, form a link between an old theme and new techniques. The colonial attitude, depicting the bush as an alien, often frightening frontier, is illustrated by methods which express the emerging native-born sense of identity with the surroundings.

But despite the dedication of a small number of artists and the high quality of their work, the closing years of the nineteenth century saw a depressing lack of interest in Australian art. The Heidelberg school had aimed at painting the kind of pictures that would be unmistakably Australian. Scenes that previously were considered to lack pictorial qualities, such as mining or pastoral activities, were now seen as an exciting challenge. But the public was not yet ready to support this challenge. Streeton and Roberts, the leading innovators, found they could not make a living by painting the landscape they loved. Separately, they sailed for England where they hoped to find a place in the art world of Europe.

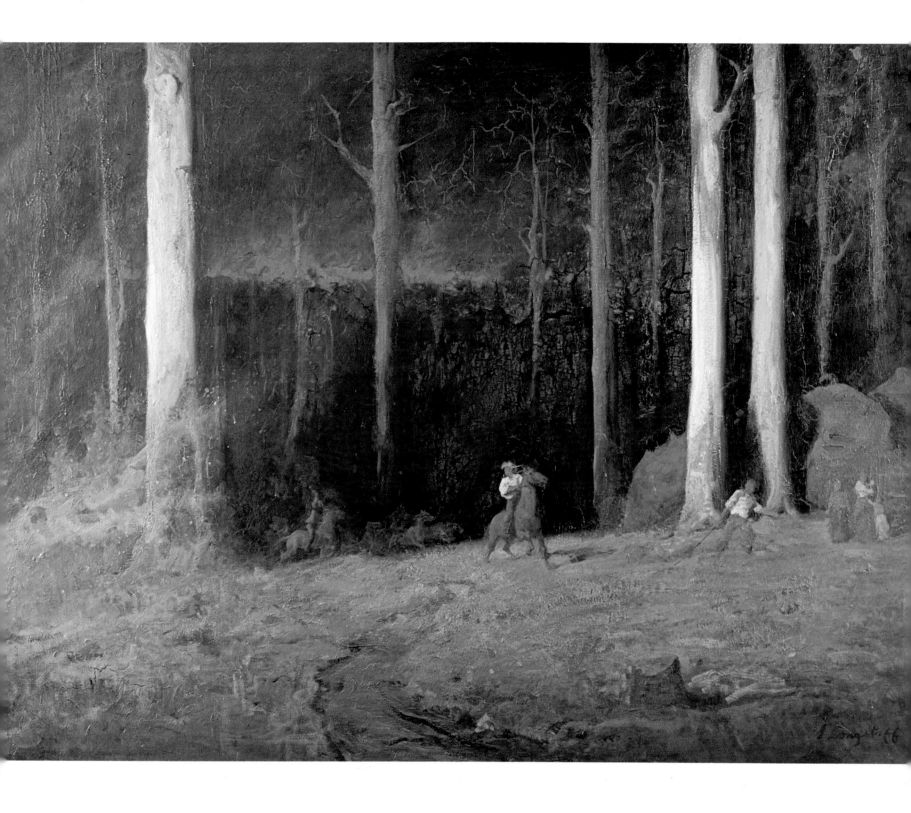

37 PLATE 27 John Longstaff *Gippsland, Sunday night, Feb. 20th 1898* (1898)

PLATE 28 David Davies *From a distant land* (1889)

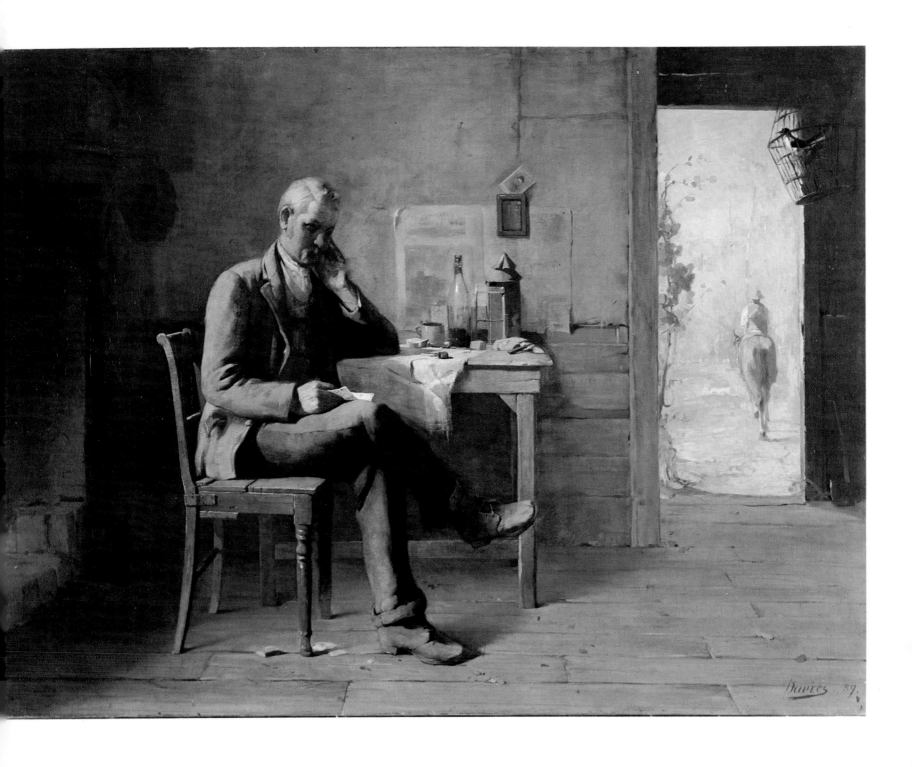

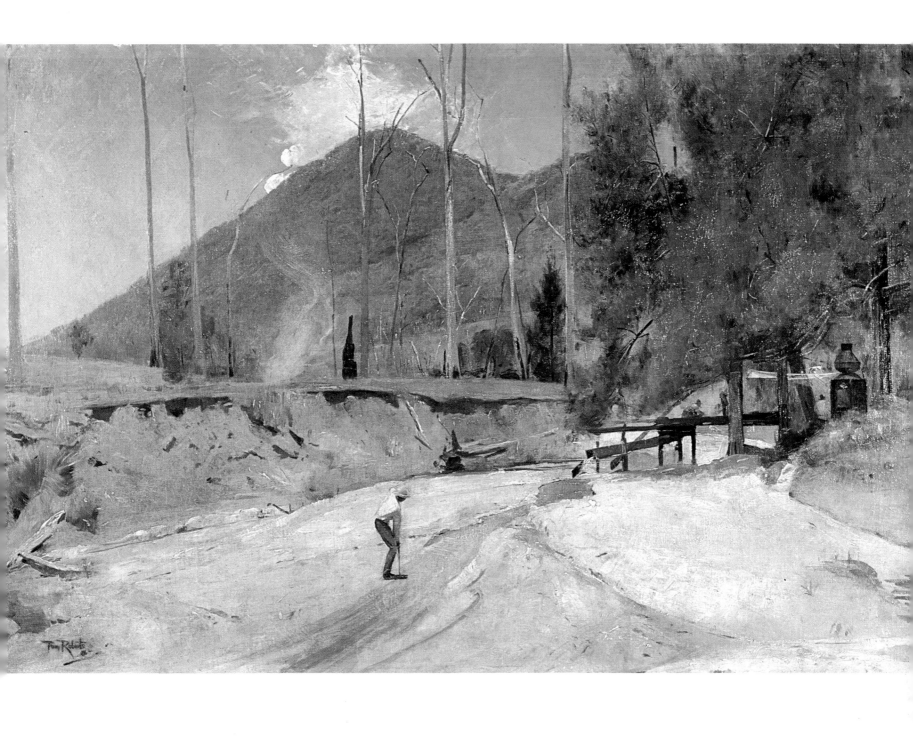

39 PLATE 29 Tom Roberts *On the Timbarra — Reek's and Allen's sluicing claim* (c. 1895-6)

PLATE 30 Tom Roberts *The golden fleece: shearing at Newstead* (1894)

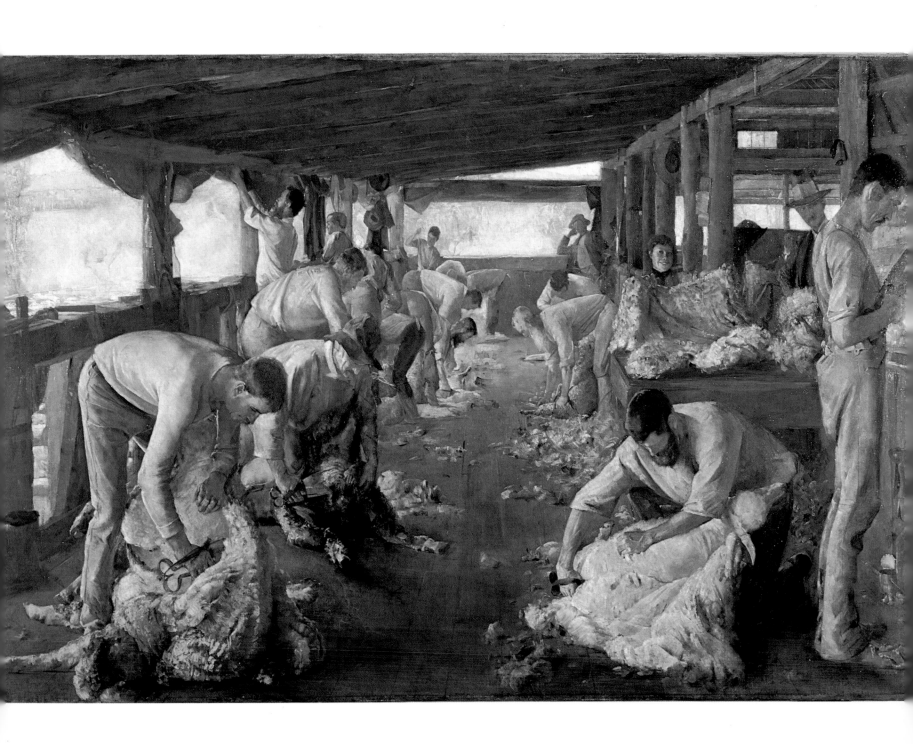

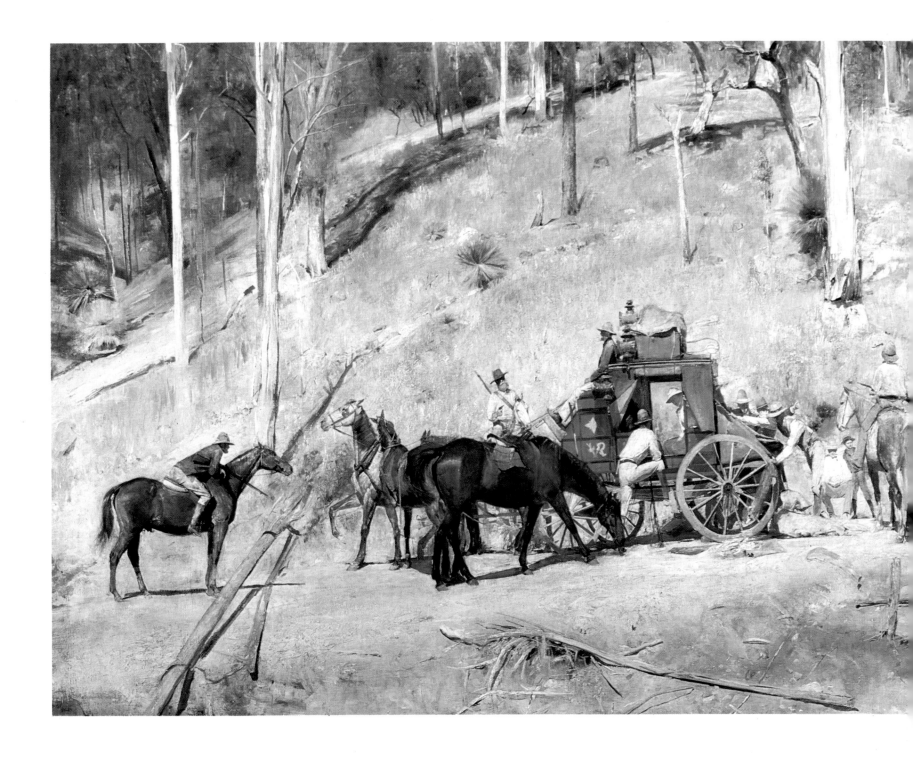

41 PLATE 31 Tom Roberts *Bailed up* (1895-1927)

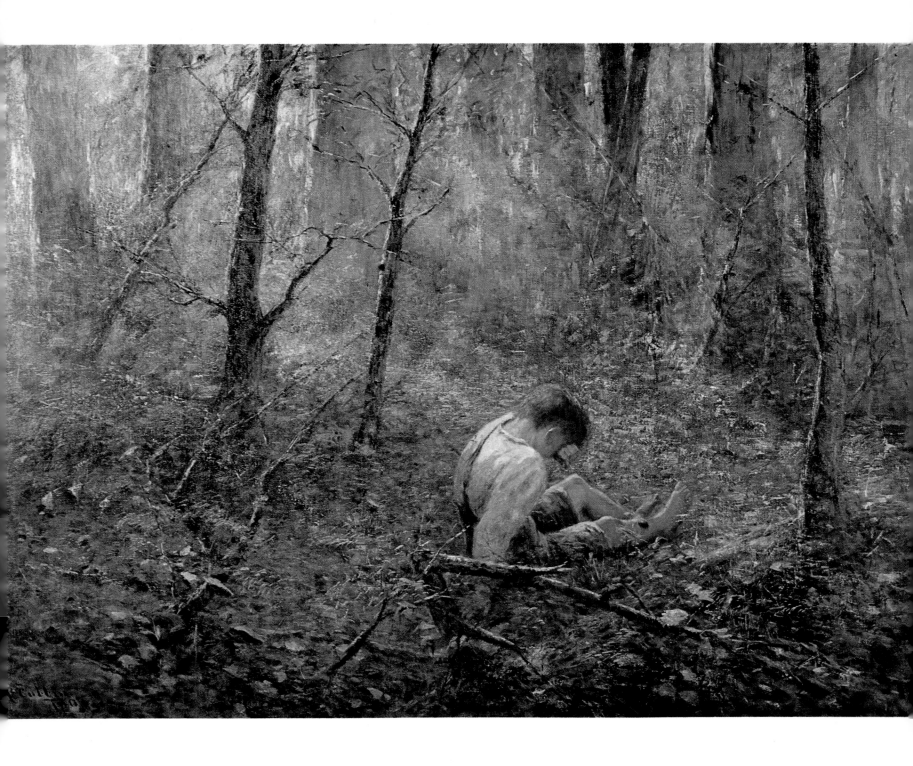

42 PLATE 32 Frederick McCubbin *Lost* (1907)

PLATE 33 Frederick McCubbin *The pioneer* (1904) (detail)

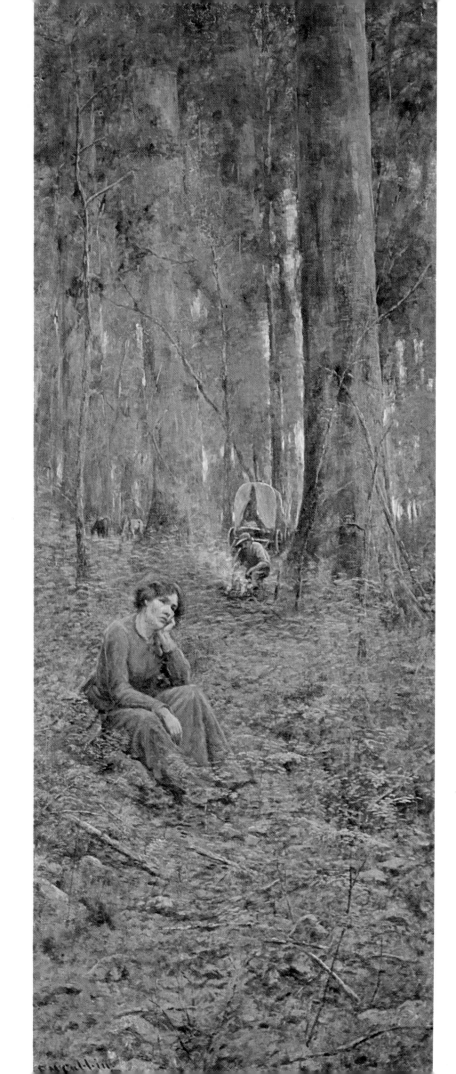

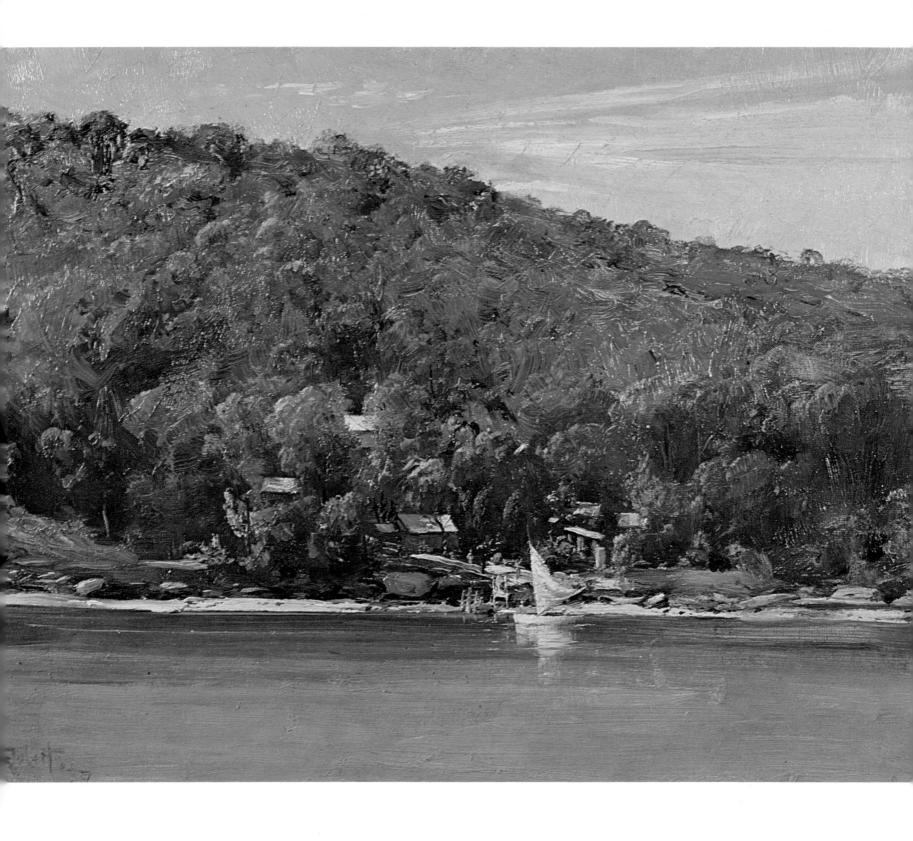

44 PLATE 34 Tom Roberts *The camp, Sirius Cove* (1899)

A Farewell to the Days of the Pioneers

In the first years of the twentieth century the spacinos vision of the bush which had inspired the work of both poet and painter in the 1880s and 1890s gave way before the experience of the harsh realities of life on the land. Yet as more people moved to the towns and lost contact with the country the artists' view of the native landscape became tinged with lyrical romanticism.

The soft, atmospheric watercolours of J. J. Hilder and Penleigh Boyd, and the later paintings of McCubbin all evoke a certain nostalgia for the beauty of the bush. Their works were not representative of the changing attitudes in art. In Europe Post Impressionism was the current vogue — a movement which had developed as a reaction against Impressionism and had as its chief aim either a return to a more formal conception of art or a new stress on the importance of the subject. In Australia, however, apart from a few young Sydney painters such as Grace Cossington Smith, Roy de Maistre and Roland Wakelin, who experimented with the new techniques, the *plein-air* mode of painting, as exemplified by McCubbin, continued to dominate popular taste until well into the late 1930s.

In the years following the early Box Hill camp McCubbin and his family lived in several suburbs on the semi-rural outskirts of Melbourne, but as the city grew he moved to Mount Macedon, a hill resort about eighty kilometres from Melbourne. Here the luxuriance of the bush foliage and the tranquillity of the setting inspired some of his most lyrical and colourful paintings. The public, however, remained largely unresponsive to local painters. The lack of buyers for his paintings and feelings of isolation from his friends now living abroad turned McCubbin's thoughts to Europe. He wrote gloomily after a one-man show in 1904: 'The papers gave me splendid notices . . . but the receipts were a few pounds over the expenses. . . I made a big effort and I honestly think the work was the best I have ever done . . . but the indifference that is allied to contempt underlies all that Melbourne cares for art'.

It was at this time that McCubbin's bush genre pictures reached their climax in a large tryptich *The pioneer* (PLATE 33). Although a sentimental painting, it truthfully reflected the spirit of a sentimental age. It was exhibited at his unsuccessful exhibition and the following year, after McCubbin had reworked part of it and added a distant view of Melbourne to the background of the third panel, it was offered to the National Gallery of Victoria. After much debate and dissension among the trustees, the work was eventually acquired for three hundred and fifty guineas. McCubbin was now able to realise his ambition to travel, and in 1907 he left for Europe with a purseful of gold sovereigns from his grateful students at the gallery drawing school.

He was to return after a year's travel consumed with admiration for the masters of European art, and particularly fascinated by the use of light in the work of the great English landscape painter Turner. Although the domestic bushland scenes (PLATES 37 and 39) painted before his European trip showed the increasing influence of Impressionism, his studies abroad confirmed and strengthened his technique. Both *Study* (PLATE 36) and *Rabbit burrow* (PLATE 38) are warm, tender portraits of the bush, in atmosphere quite removed from the melancholy of his large, pioneering themes.

While McCubbin's experience of European art consolidated his technique and his artistic vision, Roberts' sojourn in England unfortunately produced the opposite effect. In London he worked on

a large painting commissioned to commemorate the opening of the first Australian federal parliament in 1901. The commission brought relief from Roberts' financial burdens, but at considerable cost to his health and art. The work involved the execution of two hundred and fifty portraits, many of which had to be done in England, and the enormous painting took three years to complete. Although it was exhibited at the Royal Academy it was not artistically significant and it left Roberts with his sight impaired and his confidence shaken. Despite his hopes, he was able to establish only a modest reputation in England, and his paintings had none of the vitality and structural strength of his Australian work. His colours became pastel and cautious, the subjects dull and academic.

In 1923 Roberts returned to Australia, where he continued to paint until his death in 1931, but he never attained in his lifetime the recognition that his own artistic achievements or his persevering fight for the cause of Australian art deserved. The sombre atmosphere of his *Sherbrooke Forest* (PLATE 40), painted while he lived at Kallista in the Dandenong ranges near Melbourne, indicates an older, less optimistic vision.

Arthur Streeton, on the other hand, became the only artist of the Heidelberg school to achieve fame and recognition during his lifetime. The success of his first one-man show in 1896, and the favourable reception of an exhibition of Australian paintings in London, led Streeton to feel optimistic about his London prospects but he found after several lean years there that English audiences were not interested in Australian landscapes. His prestige in Australia, however, had accumulated in his absence, and he returned in 1906 to find a great demand for his work.

He had by now abandoned the simple, homely landscapes of his youth and was concentrating on expansive and panoramic views. Although Australians were now buying paintings of their own country, local collectors still maintained strong ties with Britain, and the influence of British tradition in Streeton's work no doubt contributed towards his success. *The untidy bush* (PLATE 35) is one of the few examples in Streeton's work of a detailed close-up of the bush. It would have had none of the popular appeal that *The valley from Kennon's* (PLATE 41), painted on his return to Australia after the war, would have had with an audience renewed with nationalistic and patriotic fervour. Streeton won the Wynne Prize for landscape painting in 1928 and was knighted for his services to art six years before his death in 1943.

Between the wars, schools teaching modern European art theories opened in Melbourne and Sydney. Initially they attracted only a small minority of students. Painters of this period tended to fall into two camps: those who could carry on the ideas begun at Heidelberg, and those — the vast majority — who attempted to do this but could produce only technically acceptable mutations.

The work of Lloyd Rees, born in 1895, illustrates a synthesis of European and Australian culture that perhaps was not possible for his predecessors. Rees spent his formative early years in Brisbane, isolated from the more conservative pressures prevailing in the major cities, and was thus able to develop a more individual style. In 1923 he spent a year studying in Rome and London, and his interest in architecture (particularly the Gothic style) merged in his painting with the natural forms of his own country. *Golden autumn, Lane Cove* (PLATE 42) demonstrates Rees' ability to select, arrange and stress the natural components of the scene before him to produce the essential effect of the whole. It is an Australian scene rendered in an original but classical manner and indicates the direction of the more recent and sophisticated interpretations of the Australian bush illustrated in the last section of this book.

PLATE 35 Arthur Streeton *The untidy bush* (undated)

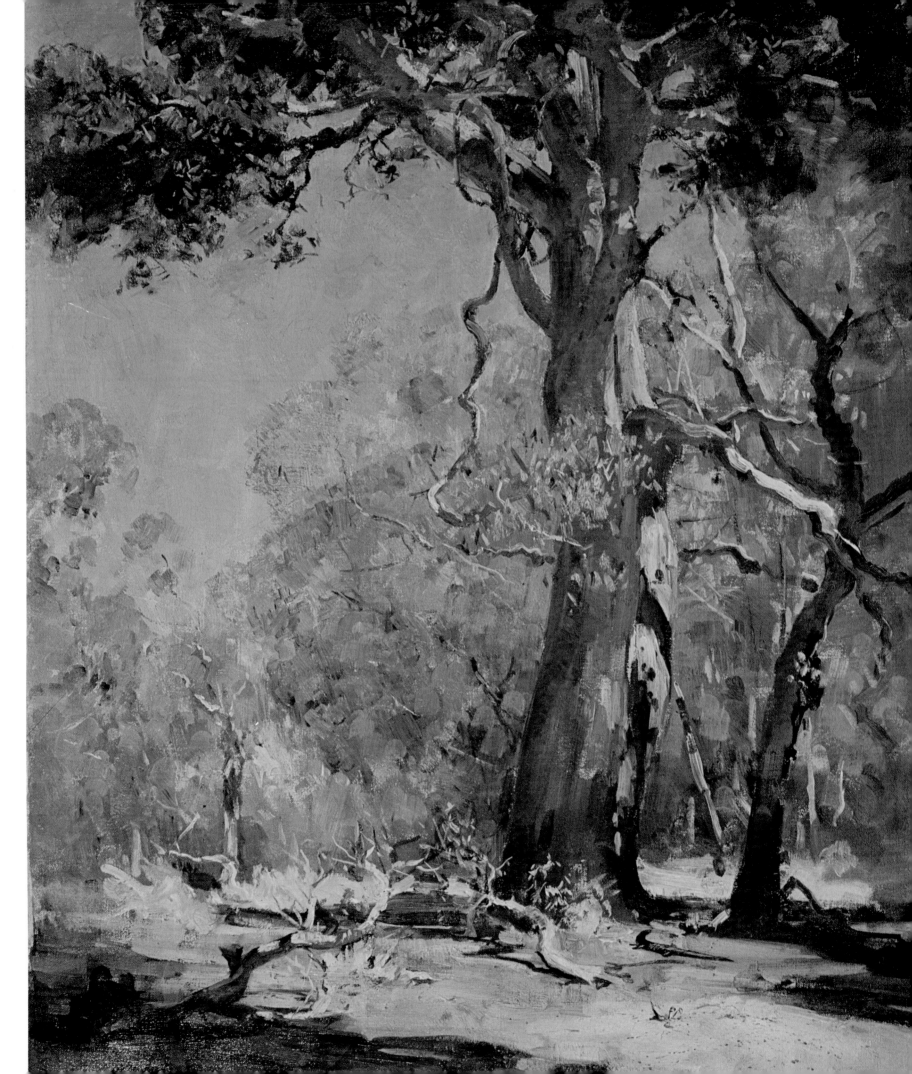

PLATE 37 Frederick McCubbin *Wattle glade* (1905)

PLATE 36 Frederick McCubbin *Study, South Yarra* (undated)

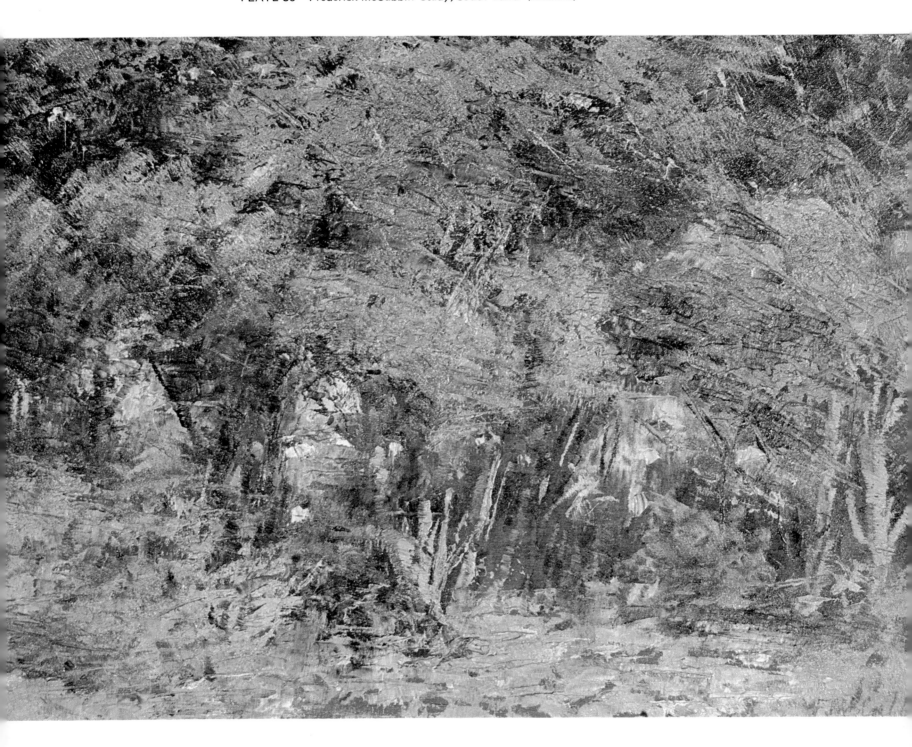

PLATE 37

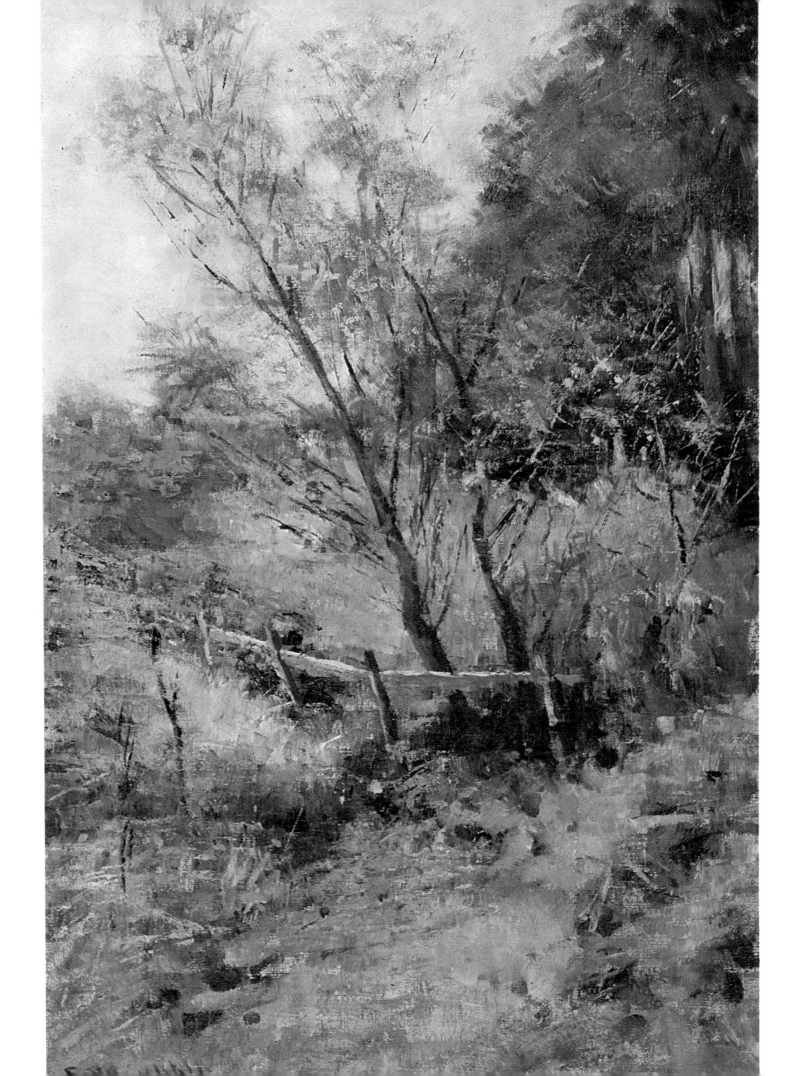

PLATE 39 Frederick McCubbin *Cottage, Macedon* (undated)

PLATE 38 Frederick McCubbin *The rabbit burrow* (1912)

PLATE 39

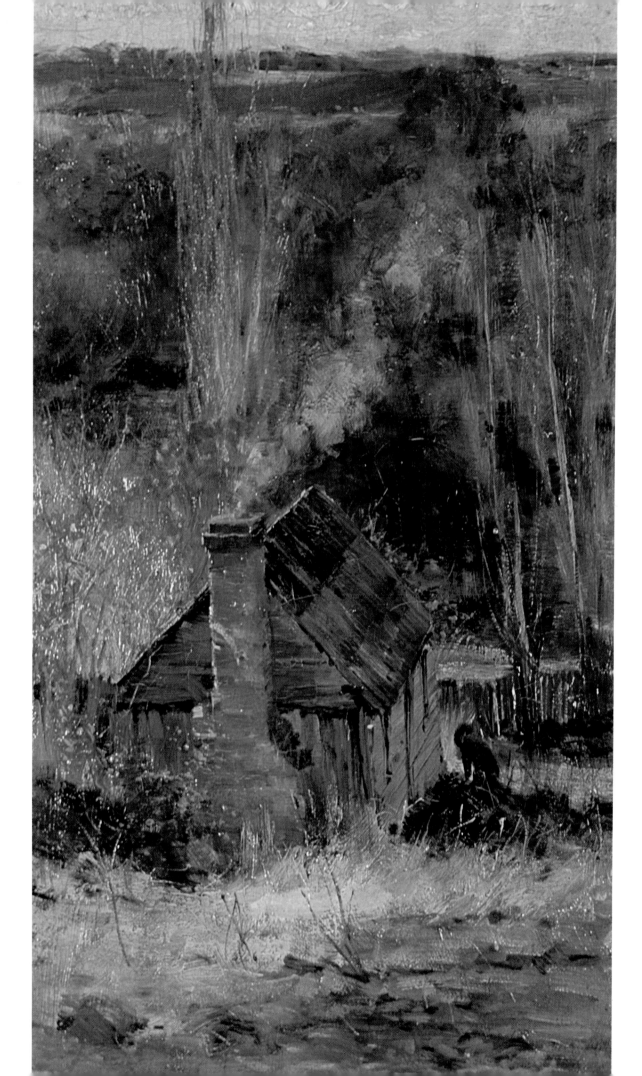

52 PLATE 40 Tom Roberts *Sherbrooke Forest* (1924)

PLATE 41 Arthur Streeton *The valley from Kennon's* (1924)

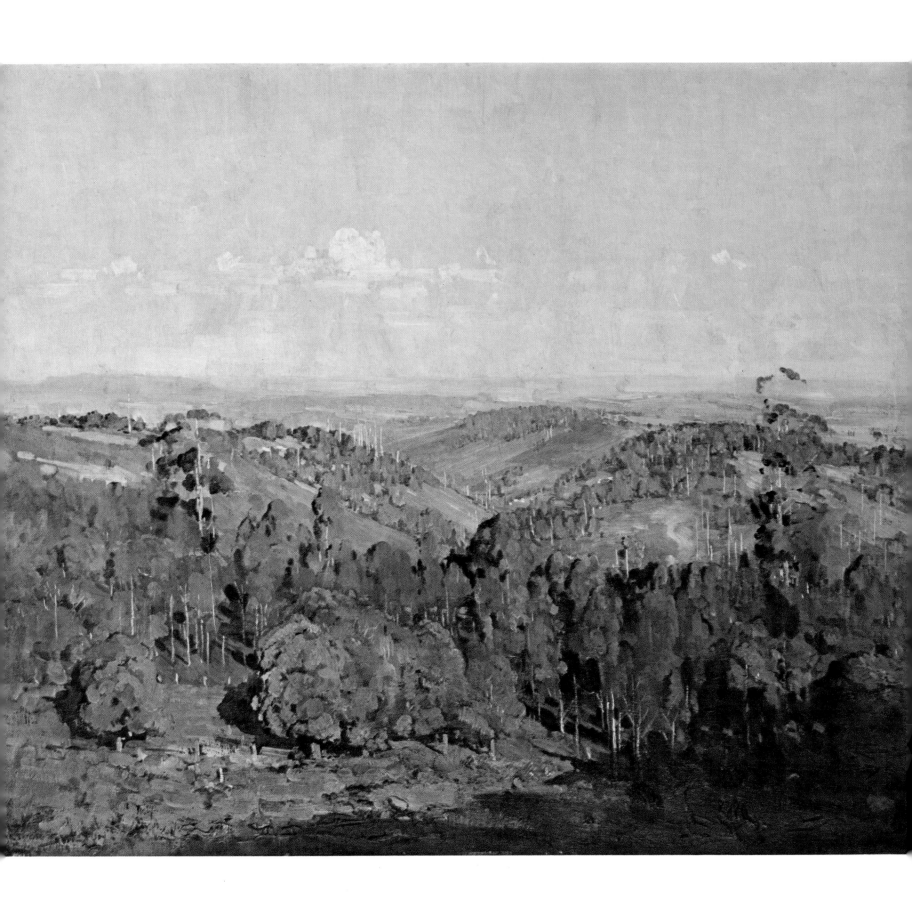

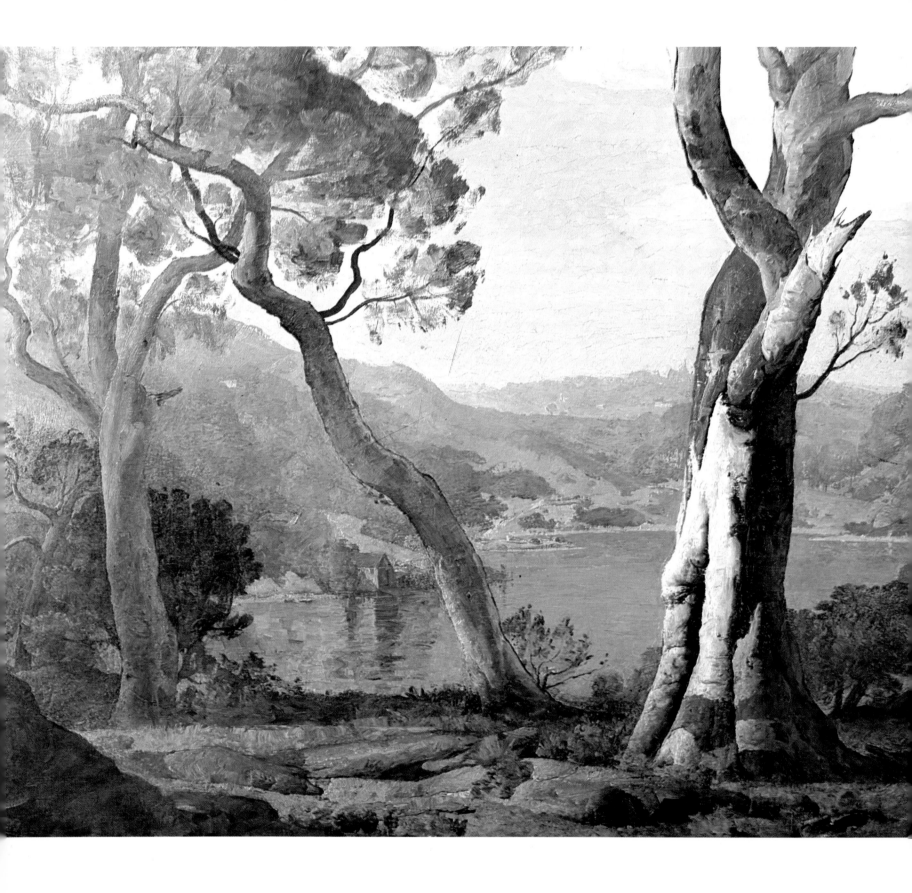

54 PLATE 42 Lloyd Rees *Golden autumn, Lane Cove River* (1937)

The Moderns Seek New Bush Symbols

The Second World War, the influx of European migrants and the return of many expatriate artists, all helped to change Australian attitudes to the land and consequently to its artistic interpretation. Areas of the continent previously inaccessible and unknown to most Australians became familiar through the paintings of Russell Drysdale, Sidney Nolan and other artists who were able to adapt European styles and techniques in formulating new Australian visions.

As had happened in the 1880s the public became receptive to Australian painting at a time when artists were seeking renewed inspiration in the landscape. But now painters were concerned not so much to express a delight in the Australian countryside itself as to convey the ideas generated by contact with it. Russell Drysdale, a pupil of George Bell's, was the first artist to draw attention to the psychological as well as the physical aspects of the Australian interior — to the loneliness and awesomeness of the Outback. Drysdale was followed by a group of Melbourne artists — of whom the best-known are Sidney Nolan, Arthur Boyd and Albert Tucker — whose imagination and skill produced the most exciting and important art since the Heidelberg school. These artists were mostly self-taught; disdaining formal art training they formed a conscious *avant garde* in much the same way as the Heidelberg artists before them.

Sidney Nolan was one of the earliest and most radical members of the Contemporary Art Society, founded in 1938, and shared with its members a fascination for the work of Klee, Picasso, Van Gogh and Miro, as well as an interest in experimental literature. It was after a period of army service in country training camps that his vision of the land and methods of describing it began to take shape. The use of historical hero-figures such as Ned Kelly, Eliza Frazer and Burke and Wills enabled Nolan to explore imaginatively the relationship of man to his environment; to describe the essential experience of being an Australian. The ghostly starkness of the trees and the greasiness of clay banks in the Stringy Bark Creek painting (PLATE 48) are visualised as Ned Kelly must have experienced them. Nolan has produced several series on the Kelly theme, concentrating initially on the activities of the bushrangers and gradually moving the focus of attention, as in this later version, to the primeval qualities of the landscape.

Like Nolan, Arthur Boyd repeatedly uses myths as a way of expressing the human condition and of placing human beings in the Australian landscape. The dark, secret, closely-treed gullies of Boyd's early paintings echo the threatening qualities of the Australian bush felt by the first arrivals to this country. The sense of alienation pervading Boyd's work, however, stems not from man's fear of the bush but of himself. Boyd's more recent Australian paintings seldom contain figures (PLATE 49). They represent an image typical of Australia: grey and subdued, silent and timeless, yet waiting.

Albert Tucker also sees the menace of the Australian bush and uses both human and animal symbols to convey the aridity of the country's vast wildernesses. *Tree* (PLATE 50) appears to be a purely realistic painting of the Australian bush, depicting many of its subtle beauties, but the great gum blisters which actually protrude from the canvas suggest the proliferation of evil forces from within. Tucker grew up in Melbourne during the depression years and was more strongly influenced

by the German Expressionists than were his contemporaries Nolan and Boyd. He became the spokesman for the left-wing, socially committed artists of the 'forties and it was not until he went to Europe that his imagery moved from urban landscapes to images of pioneer Australia – explorers, bushrangers and the desert. On his return eleven years later the bush became one of his central concerns, both as an artist and as a conservationist.

The problems associated with increasing urban growth caused many painters of the post-war generation to turn their attention to city and suburban landscapes. But in the 1960s the increasing urban sprawl and its attendant evils of pollution and destruction of the natural environment re-awakened public interest in the bushland areas on the fringes of the cities. Just as the social realist painters of the 'forties expressed concern at the inhumanity of war, so succeeding generations of artists are now making a plea through their paintings for the preservation of the natural bushlands from man's technology.

Neil Douglas, one of the most environmentally-conscious of contemporary artists, has shown, on his land near Warrandyte on the banks of the Yarra River, how the balance between man and nature can be maintained. The lovingly-observed details in his paintings of this area (PLATES 43 & 44) both document and draw attention to the fragile beauty of the native bush. His realistic paintings capture the unique quality of the Australian bush: its untidiness, its sweetness and its harshness, and the variety and odd forms of both its flora and fauna.

Clifton Pugh was another environmentally-conscious artist who lived and painted in the bush on the outskirts of Melbourne. Pugh made the observer very aware of the beauty of the bush (PLATE 45) but he also stressed its strangeness and its inherent cruelty. He was aware not only of man's potential for destruction but also of the inevitable cycle of death and regeneration in the animal and vegetable worlds. As in Aboriginal art, the form, design and colour of Pugh's paintings reveal his familiarity and understanding of the bush as a basic source of inspiration. Dedicated to the preservation of the natural environment, Pugh gave his bush property to the National Estate just prior to his death in October 1990.

Frank Hodgkinson, although not a political conservationist like Neil Douglas or Clifton Pugh, increases public awareness of the natural heritage through his evocative landscapes and detailed close-ups of bush forms. Hodgkinson uses paint not only to evoke the visual qualities of his subject but, as with the banksia (PLATE 46), its extraordinarily tactile form. Hodgkinson's preoccupation with the texture as well as the form of the Australian landscape emanated from years he spent living and working in Spain. Since his return to Australia, Hodgkinson's imaginative explorations have evoked not only the beautiful bush of the Hawkesbury River area, but also the sandy, shallow-laked areas of the Coorong and Lake Eyre in South Australia.

Unlike many of his contemporaries who elected to live in the bushland environment from which they drew their creative stimulus, Fred Williams – whose work probably more than that of any other artist has changed Australians' consciousness of the bush – lived in the city. He selected and simplified the essential elements of a particular type of country, as in *Upwey landscape* (PLATE 47), to create lyrical, perfectly balanced and accurate descriptions of the bush. The evocative patterns of gum trees, or their fire-gutted remains – aligned in forests, dotted among rocks and grass or sprouting from steep hillsides – can now be seen through Williams' aesthetic.

Although many painters prefer to express themselves through realistic, figurative descriptions of the bush, the last three decades of Australian art have produced a great variety of new pictorial languages: abstract, conceptual and minimal art – to name only a few. All have contributed to Australia's need, as a relatively young nation, to know its own image in the form of art. And as the Heidelberg painters saw new pictorial qualities in the landscape, so the present generation of artists is extending both our vision and our understanding of the native bush.

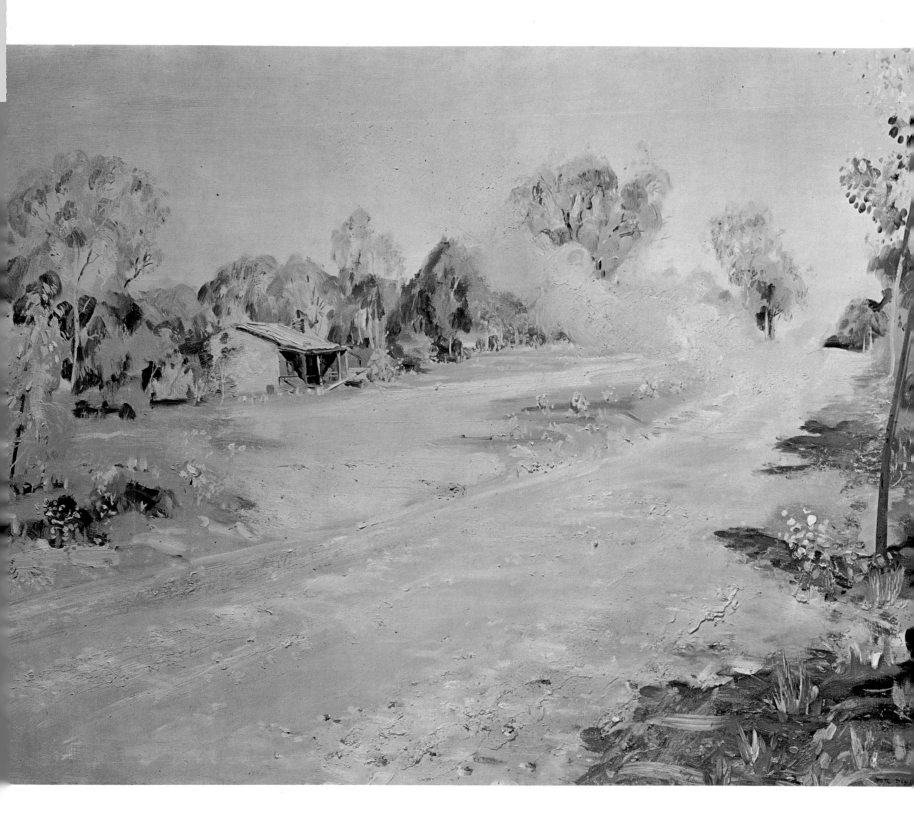

PLATE 43 Neil Douglas *Dust to dust* (c. 1964)

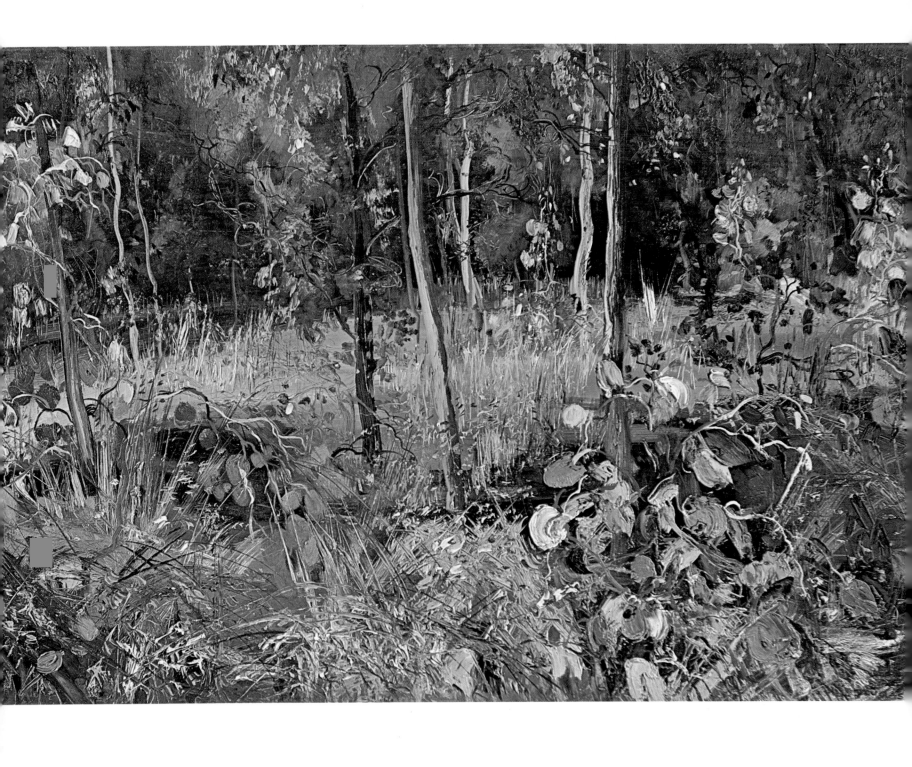

PLATE 44 Neil Douglas *Enter the wombat* (undated)

PLATE 45 Clifton Pugh *First wattle* (1975)

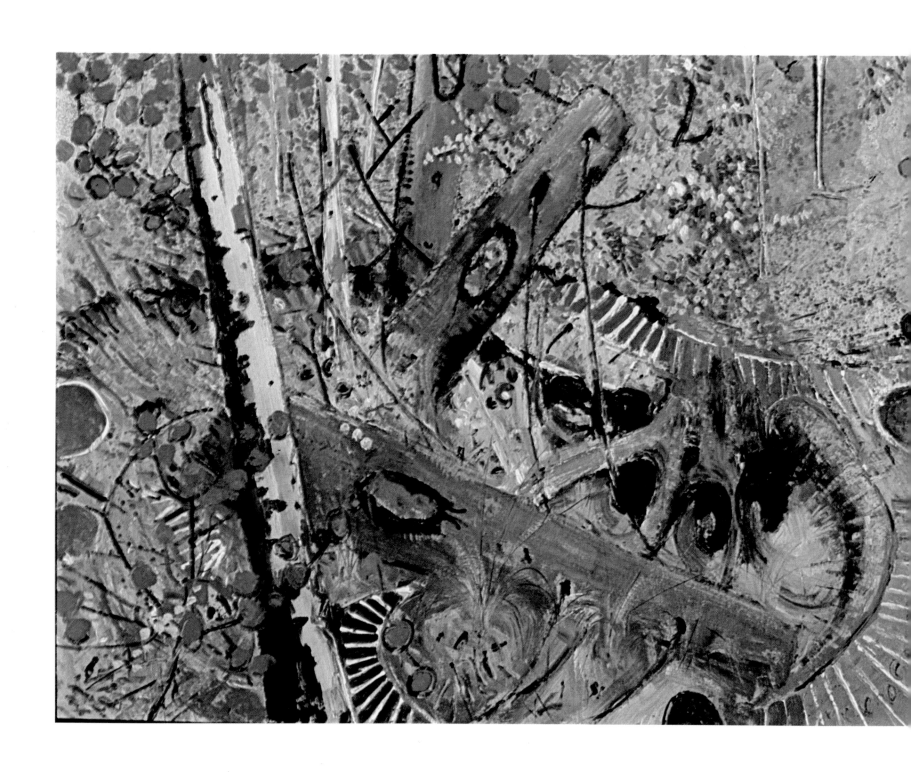

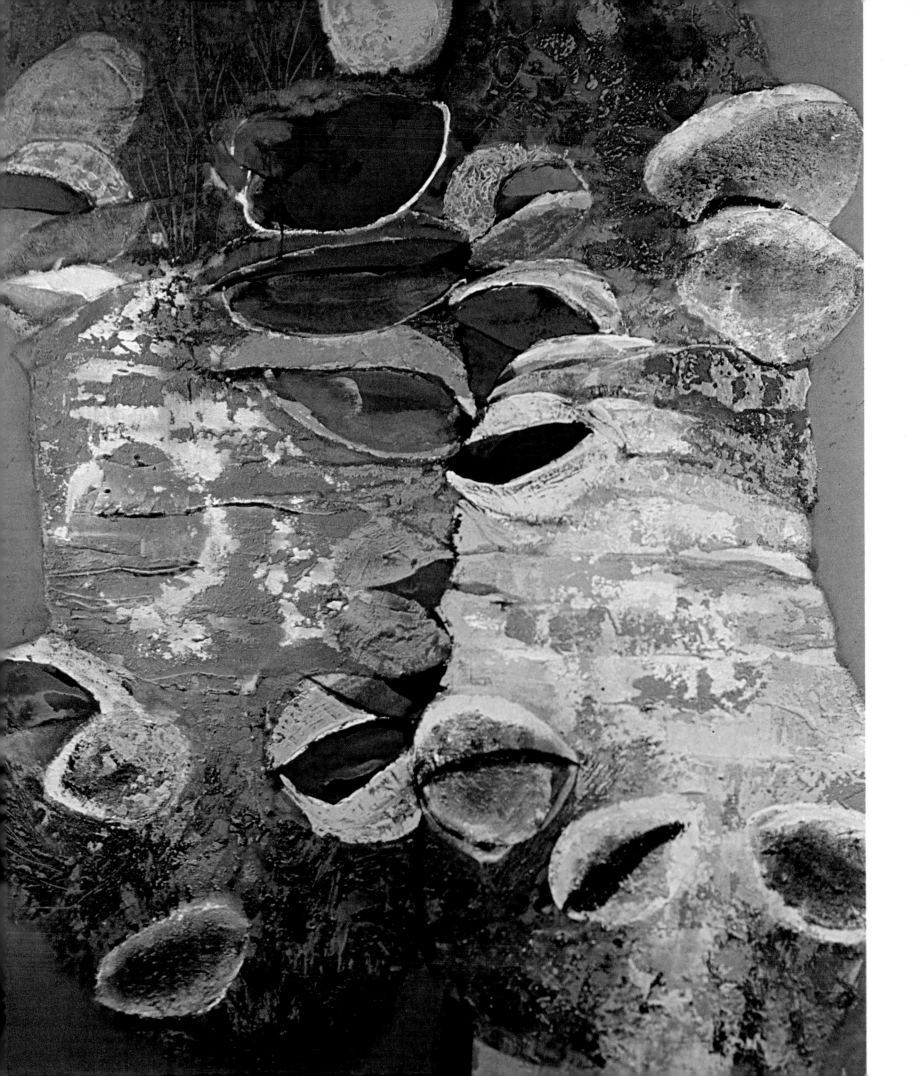

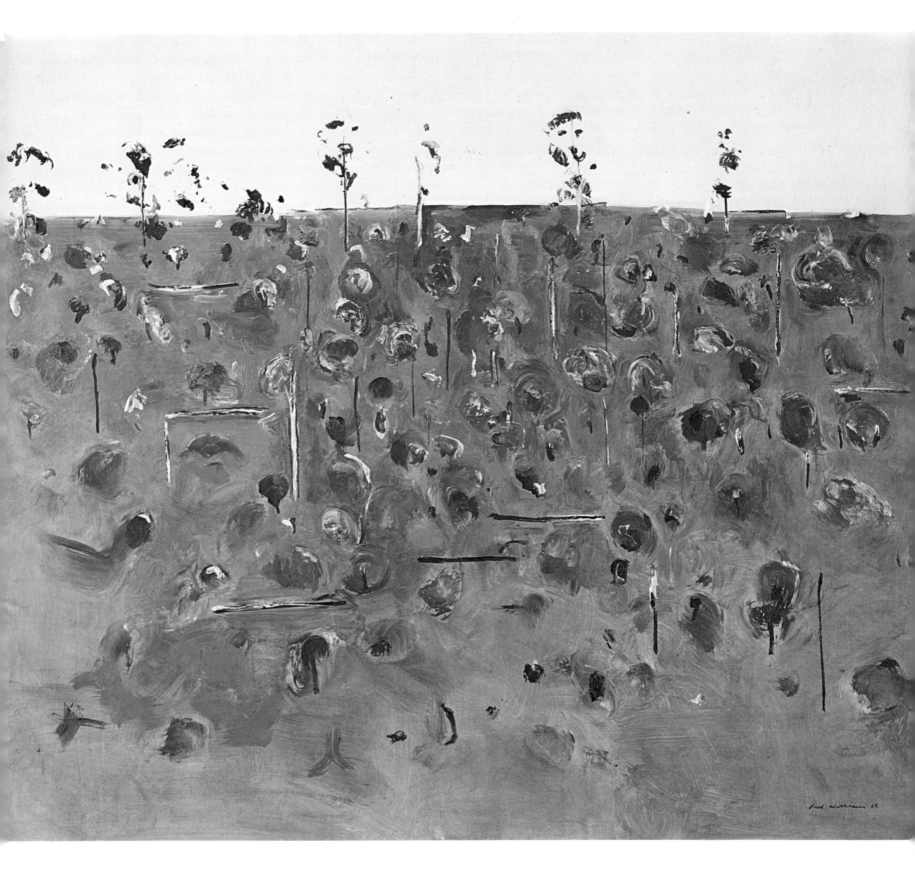

PLATE 47 Fred Williams *Upwey landscape* (1966)

PLATE 46 (Opposite) Frank Hodgkinson *Intertexture — banksias* (1972)

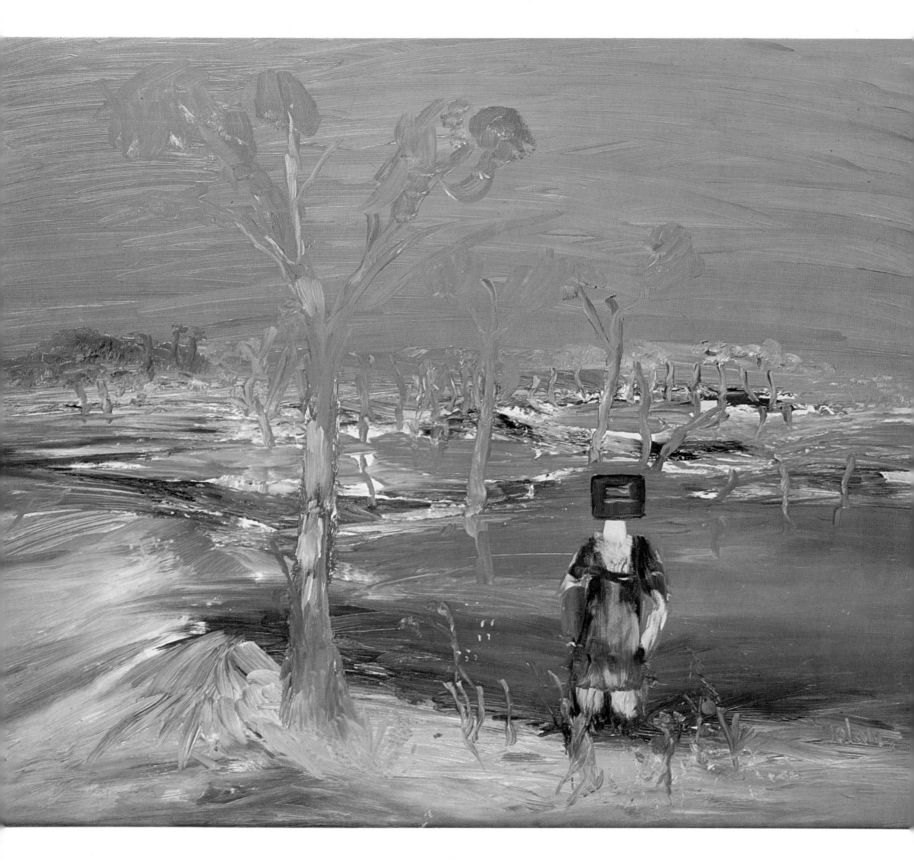

PLATE 48 Sidney Nolan *Kelly at Stringy Bark Creek* (1966)

PLATE 49 (Opposite) Arthur Boyd *Riversdale bushland* (1976)

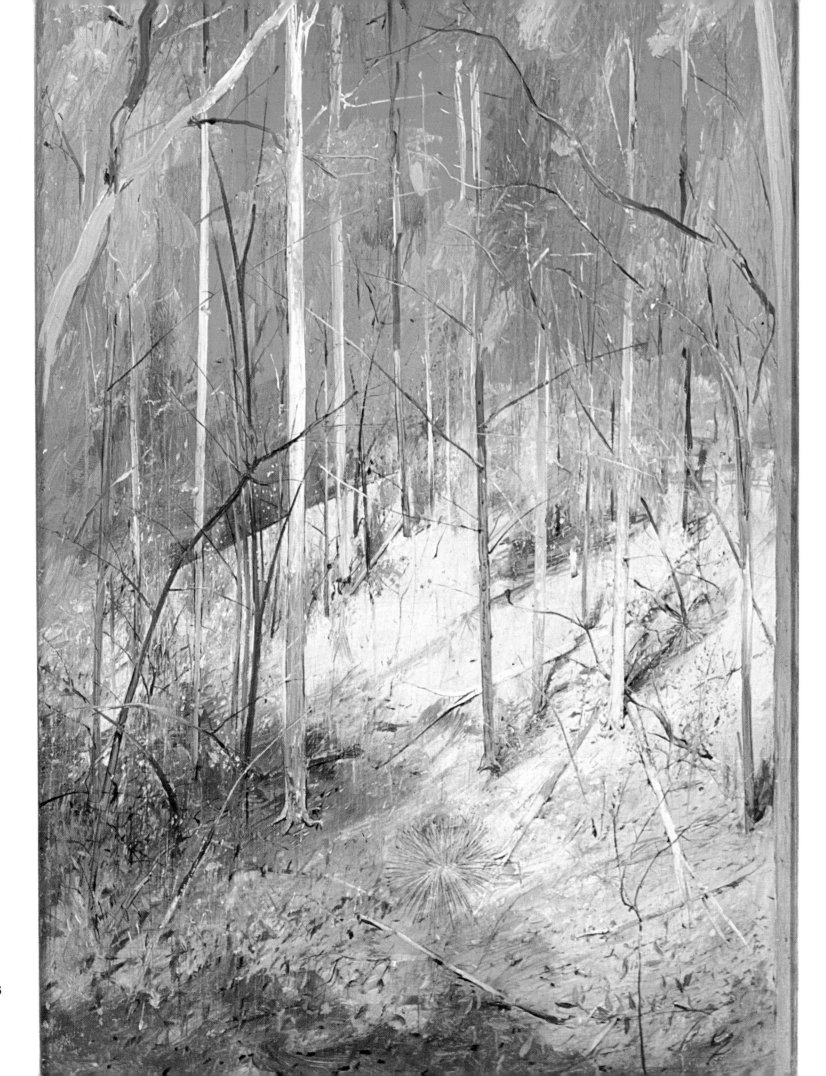

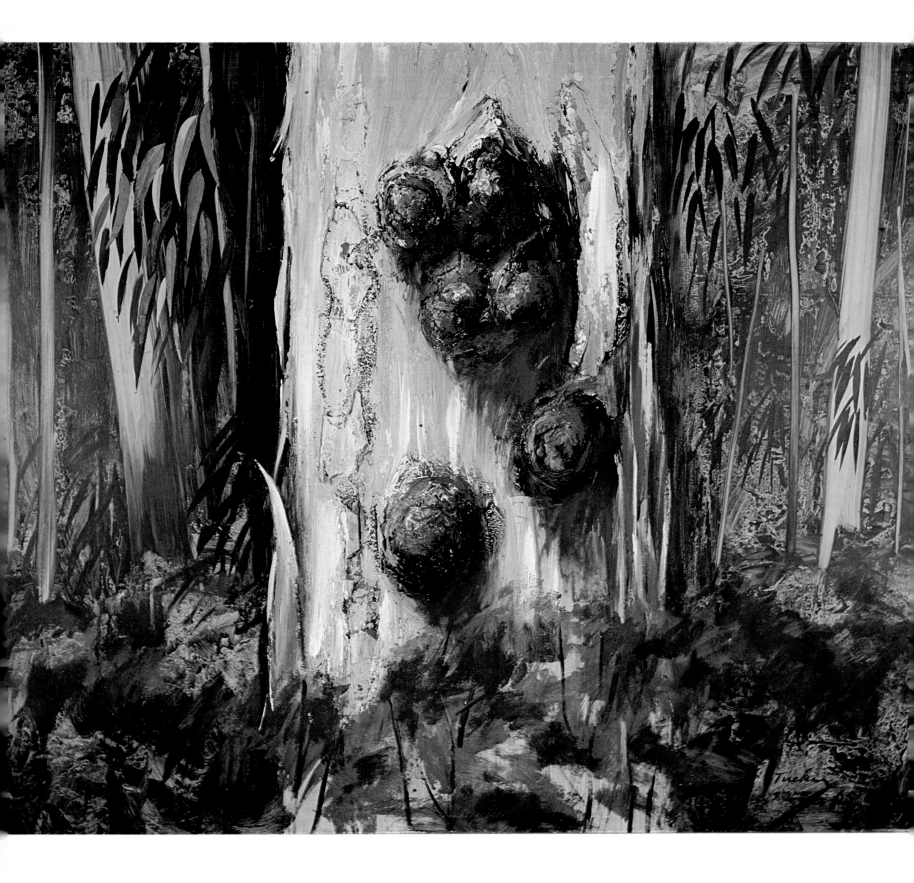

PLATE 50 Albert Tucker *Tree* (1965)

Details of the Paintings

1 TOM ROBERTS (1856—1931)
Wood splitters (The charcoal burners) c. 1886
Oil on canvas 61.4 x 92.3
Ballarat Fine Art Gallery, Victoria

2 ARTHUR STREETON (1867–1943)
The selector's hut 1890
Oil on canvas 66 x 35.5
Australian National Gallery, Canberra
Reproduced by courtesy of Oliver Streeton

3 JOHN LEWIN (c.1769–1819)
Evans Peak 1815
Watercolour 22 x 26.6
Mitchell Library, Sydney

4 JOHN LEWIN (c.1769–1819)
Springwood 1815
Watercolour 22.2 x 27.3
Mitchell Library, Sydney

5 AUGUSTUS EARLE (1793–1838)
Cabbage Tree Forest, Illawarra, New South Wales c.1827
Watercolour 25.4 x 17.1
Rex Nan Kivell Collection
National Library of Australia, Canberra

6 JOHN GLOVER (1767–1849)
The River Nile, Van Diemen's Land c.1838
Oil 76.2 x 114.3
National Gallery of Victoria, Melbourne

7 JOHN GLOVER (1767–1849)
Launceston and the River Tamar c.1834
Oil on canvas 76.7 x 113.3
Art Gallery of New South Wales, Sydney

8 EUGENE VON GUERARD (1811–1901)
The River Goulburn, near Shepparton c.1862
Lithograph 23 x 35.5
Plate *Australian Landscapes* 1867

9 EUGENE VON GUERARD (1811–1901)
Fern Tree Gully, Dandenong Ranges, Victoria c.1856
Lithograph 22.5 x 35.5
Plate *Australian Landscapes* 1867

10 EUGENE VON GUERARD (1811—1901)
Mount Kosciusko seen from the Victorian border (Mount Hope Ranges) 1866
Oil on canvas 107 x 153
National Gallery of Victoria, Melbourne

11 SAMUEL THOMAS GILL (1818—1880)
The avengers (undated)
Watercolour 38.7 x 64.1
National Gallery of Victoria, Melbourne
Purchased 1954

12 EDWARD ROPER (?—1880)
Kangaroo hunt, Mt Zero, the Grampians, Victoria 1880
Oil 60.9 x 91.4
Rex Nan Kivell Collection
National Library of Australia, Canberra

13 HENRY RIELLY (active 1870s)
Landscape near Ballan, Victoria 1877
Oil on canvas 59.7 x 101.6
National Gallery of Victoria, Melbourne
Purchased 1954

14 WILLIAM FORD (active 1870s)
*Picnic party at Hanging Rock near Mt
Macedon* 1875
Oil on canvas 78.9 x 117.3
National Gallery of Victoria, Melbourne
Purchased 1950

15 LOUIS BUVELOT (1814—1888)
Bush scene 1878
Watercolour 21 x 27.7
National Gallery of Victoria, Melbourne
Presented by John H. Connell, 1914

16 LOUIS BUVELOT (1814—1888)
Mt Martha from Dromana's hill 1877
Oil on canvas 48.2 x 71.1
National Gallery of Victoria, Melbourne
Presented from the estate of the late
Miss A. R. C. Robertson, 1964

17 TOM ROBERTS (1856—1931)
The artists' camp 1886
Oil on canvas 45.7 x 60.8
National Gallery of Victoria, Melbourne
Felton Bequest 1943

18 TOM ROBERTS (1856—1931)
A summer morning tiff 1887
Oil on canvas 76.5 x 51.2
Ballarat Fine Art Gallery, Victoria

19 FREDERICK McCUBBIN (1855—1917)
Down on his luck 1889
Oil on canvas 114.5 x 152.5
Western Australian Art Gallery, Perth
Purchased 1896

20 FREDERICK McCUBBIN (1855—1917)
Lost 1886
Oil on canvas 115.8 x 73.7
National Gallery of Victoria, Melbourne
Felton Bequest 1940

21 ARTHUR STREETON (1867—1943)
Impression — roadway 1889
Oil on cardboard 14.6 x 24.1
National Gallery of Victoria, Melbourne
Purchased 1955
Reproduced by courtesy of Oliver Streeton

22 ARTHUR STREETON (1867—1943)
The clearing, Gembrook 1888
Oil on canvas 25.4 x 45.7
National Gallery of Victoria, Melbourne
Felton Bequest 1942
Reproduced by courtesy of Oliver Streeton

23 ARTHUR STREETON (1867—1943)
Twilight pastoral 1889
Oil on canvas 65.5 x 33
Reproduced by courtesy of Oliver Streeton

24 ARTHUR STREETON (1867—1943)
Blossoms, Box Hill 1890
Oil on canvas 43.8 x 64.8
National Gallery of Victoria, Melbourne
Purchased with the assistance of a special grant
from the Government of Victoria 1979/1980
Reproduced by courtesy of Oliver Streeton

25 FREDERICK McCUBBIN (1855—1917)
The letter 1884
Oil on canvas 69.1 x 51
Ballarat Fine Art Gallery, Victoria

26 FREDERICK McCUBBIN (1855—1917)
On the wallaby track 1896
Oil on canvas 122 x 223.5
Art Gallery of New South Wales, Sydney

27 JOHN LONGSTAFF (1862—1941)
Gippsland, Sunday night, Feb. 20th 1898
1898
Oil on canvas 143.5 x 196.2
National Gallery of Victoria, Melbourne
Purchased 1898

28 DAVID DAVIES (1862—1939)
From a distant land 1889
Oil on canvas 80.9 x 115.6
Art Gallery of New South Wales, Sydney

29 TOM ROBERTS (1856—1931)
*On the Timbarra — Reek's and Allen's
sluicing claim* c. 1895-6
Oil on canvas 66.5 x 102.5
Art Gallery of New South Wales, Sydney

30 TOM ROBERTS (1856—1931)
The golden fleece: shearing at Newstead
1894

Oil on canvas 104 x 158.5
Art Gallery of New South Wales, Sydney

31 TOM ROBERTS (1856–1931)
Bailed up 1895-1927
Oil on canvas 53 x 72
Art Gallery of New South Wales, Sydney

32 FREDERICK McCUBBIN (1855–1917)
Lost 1907
Oil on canvas 198.7 x 134.6
National Gallery of Victoria, Melbourne
Felton Bequest 1941

33 FREDERICK McCUBBIN (1855–1917)
The pioneer 1904
Oil on canvas, tryptich; first panel 225 x 86
National Gallery of Victoria, Melbourne
Felton Bequest 1906

34 TOM ROBERTS (1856–1931)
The camp, Sirius Cove 1899
Oil on canvas 25.4 x 34.6
Art Gallery of New South Wales, Sydney

35 ARTHUR STREETON (1867–1943)
The untidy bush undated
Oil on canvas 62.2 x 75.2
National Gallery of Victoria, Melbourne
Felton Bequest 1934
Reproduced by courtesy of Oliver Streeton

36 FREDERICK McCUBBIN (1855–1917)
Study, South Yarra undated
Oil on hardboard 25.4 x 35.9
National Gallery of Victoria, Melbourne
Purchased 1960

37 FREDERICK McCUBBIN (1855–1917)
Wattle glade 1905
Oil on canvas 55.9 x 35.5
National Gallery of Victoria, Melbourne
Purchased with the assistance of a special grant
from the Government of Victoria 1979/1980

38 FREDERICK McCUBBIN (1855–1917)
The rabbit burrow 1912
Oil 68.5 x 88.9
Private collection

39 FREDERICK McCUBBIN (1855–1917)
Cottage, Macedon undated
Oil on canvas 46.4 x 25.4
Art Gallery of New South Wales, Sydney

40 TOM ROBERTS (1856–1931)
Sherbrooke Forest 1924
Oil on canvas 48 x 68.4
Art Gallery of New South Wales, Sydney

41 ARTHUR STREETON (1867–1943)
The valley from Kennon's 1924
Oil 66 x 83.2
National Gallery of Victoria, Melbourne
Felton Bequest
Reproduced by courtesy of Oliver Streeton

42 LLOYD REES (1895–1989)
Golden autumn, Lane Cove River 1937
Oil on canvas 61.2 x 77
National Gallery of Victoria, Melbourne
Felton Bequest 1937

43 NEIL DOUGLAS (b. 1911)
Dust to dust c.1964
Oil on masonite 93 x 120
Private collection

44 NEIL DOUGLAS (b. 1911)
Enter the wombat undated
Oil on canvas 80 x 110.4
Monash University, Melbourne

45 CLIFTON PUGH (1924–1990)
First wattle 1975
Oil on masonite 91.4 x 121.9
Private collection

46 FRANK HODGKINSON (b. 1919)
Intertexture – banksias 1972
Mixed media on canvas 182 x 152
Private collection

47 FRED WILLIAMS (1927–1982)
Upwey landscape 1966
Oil on canvas 152.4 x 182.8
Private collection, London

48 SIDNEY NOLAN (b. 1917)
Kelly at Stringy Bark Creek 1966
Oil on canvas 57 x 73
Private collection, Victoria

49 ARTHUR BOYD (b. 1920)
Riversdale bushland 1976
Oil on copper 30 x 21
Private collection

50 ALBERT TUCKER (b. 1914)
Tree 1965
Acrylic on hardboard 121.5 x 152
Australian National Gallery, Canberra

Artists in Public Collections

ARTHUR BOYD
New South Wales, South Australian, Queensland, Western Australian and (especially) Victorian State galleries; Bendigo gallery; University of Western Australia.

LOUIS BUVELOT
New South Wales, Victorian, South Australian, Queensland and Western Australian State galleries; Bendigo, Geelong and Newcastle galleries.

DAVID DAVIES
New South Wales, Victorian and South Australian State galleries; Ballarat gallery.

NEIL DOUGLAS
Australian National Gallery, Canberra; Latrobe and Monash universities.

AUGUSTUS EARLE
Australian National Library, Canberra; Mitchell Library, Sydney.

WILLIAM FORD
National Gallery of Victoria.

S. T. GILL
New South Wales, Victorian, South Australian, Queensland, Western Australian and Tasmanian State galleries; many provincial galleries; Dixson Gallery of the Mitchell Library, Sydney.

JOHN GLOVER
Victorian, South Australian and Tasmanian State galleries; Launceston and Ballarat galleries.

FRANK HODGKINSON
New South Wales, Victorian, Queensland, and West Australian State galleries; Australian National War Memorial, Canberra; universities of New South Wales and Melbourne.

JOHN LEWIN
Mitchell Library, Sydney; Australian National Library, Canberra.

JOHN LONGSTAFF
New South Wales (22 works), Victorian, South Australian, Queensland, Western Australian and Tasmanian State galleries; Bendigo, Geelong, Ballarat and Castlemaine galleries; universities of Melbourne and Sydney; Australian National War Memorial, Canberra; National Collection, Canberra.

FREDERICK McCUBBIN
New South Wales, Victorian, South Australian, Queensland, Western Australian and Tasmanian State galleries; Bendigo, Geelong, Ballarat and Castlemaine galleries.

SIDNEY NOLAN
Victorian, South Australian, Queensland, Western Australian, Tasmanian and (especially) New South Wales State galleries; Ballarat gallery; University of Western Australia.

CLIFTON PUGH
New South Wales, Victorian, South Australian, Queensland and Western Australian State galleries; Bendigo, Ballarat and Castlemaine galleries; Australian National University, Canberra; University of Queensland.

LLOYD REES
New South Wales, Victorian, South Australian, Western Australian, Tasmanian and (especially) Queensland State galleries; Bendigo, Newcastle, Ballarat and Castlemaine galleries.

HENRY RIELLY
National Gallery of Victoria.

TOM ROBERTS
New South Wales (31 works), Victorian, South Australian, Queensland, Western Australian and Tasmanian State galleries; Bendigo, Geelong, Ballarat and Castlemaine galleries; National Collection, Canberra.

EDWARD ROPER
National Library of Australia, Canberra.

ARTHUR STREETON
New South Wales, Victorian, South Australian, Queensland and Western Australian State galleries; Bendigo, Geelong, Newcastle, Ballarat, Mildura, Shepparton and Castlemaine galleries; Australian National War Memorial (56 works), Canberra.

ALBERT TUCKER
All State galleries; Bendigo and Newcastle galleries and especially Australian National Gallery, Canberra.

EUGENE VON GUERARD
New South Wales, Victorian and South Australian State galleries; Ballarat and Geelong galleries; Mitchell Library, Sydney; State Library, Melbourne; National Collection, Canberra.

FRED WILLIAMS
Australian National Collection, Canberra; all State galleries; several provincial galleries, particularly in Victoria, and Melbourne University.

Index